DRAW
BUILDINGS
AND CITIES
IN 15 MINUTES

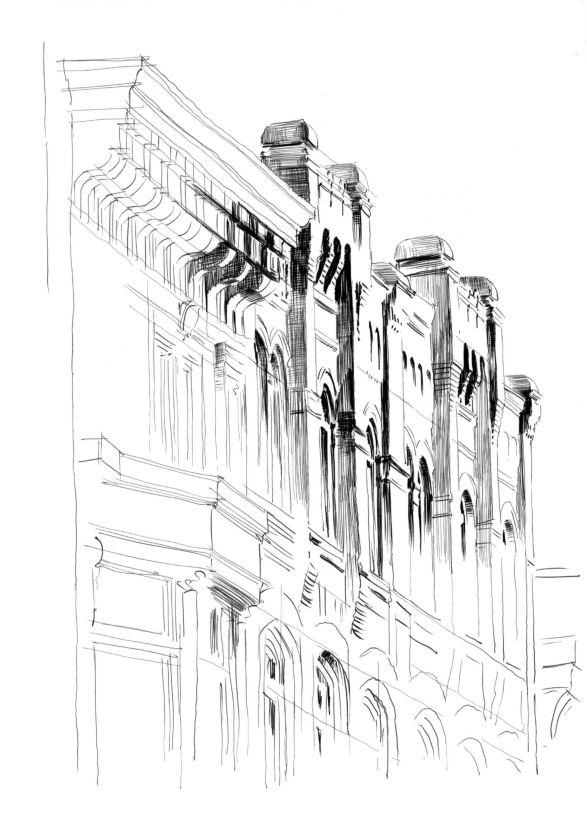

AMAZE YOUR FRIENDS WITH YOUR DRAWING SKILLS

DRAW
BUILDINGS
AND CITIES
IN 15 MINUTES

MATTHEW BREHM

ilex

An Hachette UK Company
www.hachette.co.uk

First published in the United Kingdom in 2017 by
ILEX, a division of Octopus Publishing Group Ltd
Octopus Publishing Group
Carmelite House
50 Victoria Embankment
London, EC4Y 0DZ
www.octopusbooks.co.uk
www.octopusbooksusa.com

Distributed in the US by Hachette Book Group
1290 Avenue of the Americas, 4th and 5th Floors, New York, NY 10020

Distributed in Canada by Canadian Manda Group
664 Annete St., Toronto, Ontario, Canada M6S 2C8

Publisher: Roly Allen
Editorial Director: Zara Larcombe
Managing Specialist Editor: Frank Gallaugher
Senior Project Editor: Natalia Price-Cabrera
Art Director: Julie Weir
Designers: Grade Design
Assistant Production Manager: Marina Maher

ISBN 978-1-78157-287-0

A CIP catalogue record for this book is
available from the British Library.

Printed and bound in China.

10 9 8 7 6 5 4 3 2 1

Contents

INTRODUCTION

This book is for anyone with an interest in the visual character of the cities and buildings that frame our lives. It is intended to help you capture the life of the places where we work and spend our free time, and of the places we visit in our travels both near and far. The skills and strategies presented here will help you make a visual record of the urban places you experience, and help you learn about these places in the process.

Cities and Buildings

Cities, large and small, are a physical manifestation of the ways we organize ourselves as societies. They don't always work the way we would like, and they can remind us of our less effective attempts at planning and development. Nonetheless, cities bring together humankind in all its wonderful diversity; they act as an impetus for the arts, and are magnets for commerce and the leisure time that accompanies economic development.

Cities concentrate some of our most exalted achievements in architecture and planning, and their museums, theaters, restaurants, parks, and so on, are the venues for our cultural identity and advancement. Our cities express our ideals and aspirations as societies, and are the places where we determine who we are and how we create our successes in life. As such, cities are always worth our careful analysis and consideration. Drawing is one of the most direct and effective means by which we can achieve this essential and ongoing study.

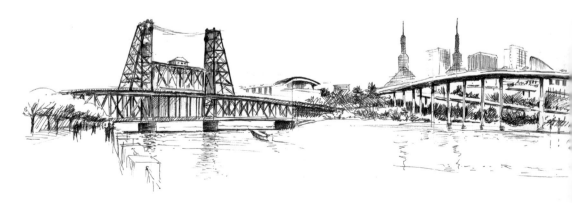

Why Draw?

At least since the dawn of recorded history, drawing has been an essential form of expression. While digital technology has recently been distracting us somewhat from engaging in authentic, handmade arts and crafts, the computer will never fully replace the connections that occur between eyes, mind, and hand in the act of drawing from observation. We may also draw because it's an enjoyable thing to do. Drawing can be relaxing, as when we doodle mindlessly to pass the time, or it can be a great challenge, as when we attempt to draw what we see with a high degree of accuracy. This book is not about trying to create "picture-perfect" images, but it is about drawing what we see rather than merely doodling or drawing from the imagination. Drawing from observation is primarily about studying the things we see in the world, and only secondarily about producing polished works.

Certainly, the end products of our efforts—the finished drawings—can sometimes stand on their own as valuable works of art. To produce such works is often a motivating factor in attracting people to the practice of drawing in the first place. But most often, in the process of learning to draw we begin to sense that drawing is valuable because it forces us to really look at our surroundings, to spend time considering the way things are in our environment, and ultimately to understand the world around us more deeply than we would have without drawing. With this type of study as the goal, the drawings themselves—their quality or completeness—are often less important than the learning they represent.

For this reason, most artists draw in sketchbooks, with no intention to hang individual drawings on the wall, and the sketchbook becomes a storehouse of experience and memories regarding places visited, observed, and studied. With instruction and practice, the artist will see improvement in the quality of their drawings, and also in their ability to complete drawings in a relatively brief span of time. Such improvement ultimately makes drawing an ever more accessible and enjoyable way to learn about the world around us.

Time and Drawing

The ability to draw well is a skill that requires learning and practice. While we all seem to have an innate ability to be expressive with our hands, no one is born with the ability to draw with great skill. People who have an apparent "talent" for drawing are those who have invested the time and effort to build their skills for seeing and drawing well.

Some individuals are certainly more motivated than others to develop their skills, and these people are far more likely to make speedy progress. But everyone must go through the time and repeated effort to develop their abilities to the degree they desire.

Learning to draw takes time, of course, and in the process of learning it will often be necessary to spend more than 15 minutes on a single drawing. Practice sessions might last 45 minutes or one hour—as long as you feel you're being productive, and not becoming frustrated by the experience, feel free to keep practicing. The ability to capture an urban scene or a particular building in 15 minutes should be seen as one goal among many with regard to drawing.

We might feel that not having enough time to complete a drawing will be frustrating, and sometimes that's true. But, though it may seem a paradox, working within small windows of time is actually a good way to combat frustration. Brief drawings help us to stay focused on repeated, short bursts of practice rather than elaborately developed drawings that require far more time without necessarily producing better results. This idea is explored further in the section on Time, Scope, Size, and Medium later in the book. For now it will be helpful to understand 15 minutes as a valuable practice technique and as a potential goal for creating lively, energetic drawings down the line.

Drawing in Public

If our drawing subjects are buildings and cities, then it's most likely that we'll be doing our work outside and in public. A great many artists do their work indoors, in a private and protected studio. There's an obvious sense of security that comes with such a situation, and we might feel a bit exposed when we're actually out and in front of others. But drawing in public involves you directly with your subjects—not only the sights, but also the sounds, aromas, and other sensations that contribute to a fuller and more memorable drawing experience.

It makes sense to blend in as much as possible and avoid making a show of what you're doing, if only to allow yourself the freedom to focus on your task. But do try to be open to others on the street who might be interested in your drawings, and don't be shy about sharing your sketchbook with them.

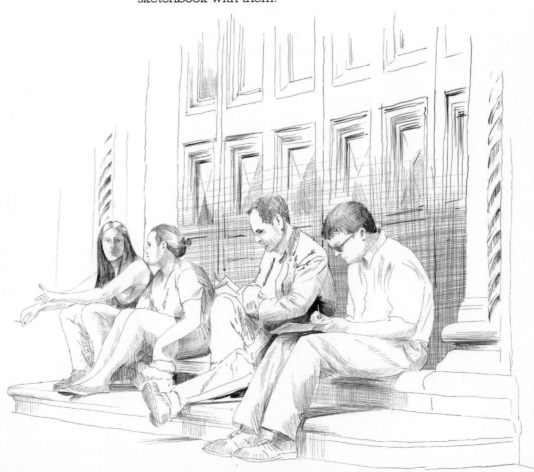

Materials

Any type of paper and any type of common writing instrument is all you truly need to begin drawing. When you are just starting to learn, the most important thing to do is simply to draw as often as possible. Regular practice is far more valuable than spending time worrying you don't have the right materials. In other words, the "right" materials are those that are most immediately available to you, provided you're using them to draw often.

As you begin to develop your drawing skills, it's a good idea to experiment with a variety of materials and take notes along the way. Become your own judge of drawing instruments and papers, and try to find combinations that you find comfortable and that give you the results you're after. With time and testing, you'll begin to care more about the tools and paper you use, but again, the most important thing to do throughout this process is practice.

This book is focused on pencils and pens because they are the most commonly available drawing tools. Portability is also a factor—a single pen or pencil is easily carried anywhere, in a pocket or purse—as is the fact that pencil or pen can be used on virtually any type of paper. (Watercolor, by contrast, requires some specialized equipment and is best used with paper that's quite thick and has been treated with "sizing," a substance that affects its absorbency.)

Pens and pencils are also the most fundamental drawing tools in terms of technique. With a pen, you will be limited to making points and lines, with tones being created through "hatching" (consistent groups of roughly parallel lines). You can achieve the same results with a pencil, but pencils are also more responsive to varying pressure— light marks from a soft touch and darker marks from a heavier touch. Pencils can also be used to create smooth tones, without having to build up many lines to create a hatch pattern.

Sketchbooks and Paper

There are a great many types of sketchbook on the market, of different sizes, formats, and paper types. Look for something portable without being too small—I find that books no smaller than 8 inches (20cm) on a side give me the page space I need to develop my drawings without pushing the margins too much. For practice drawings, having a good large page is preferred—something around 10 x 12 inches (25 x 30cm) is ideal.

Hardbound books are more durable, and they allow drawing across the entire two-page spread, but they can be challenging to hold open while drawing; ring-bound books that open completely can be more comfortable. A standard portrait-oriented sketchbook is a good place to start, but there are also landscape-oriented books that can encourage you to experiment with other compositional approaches, such as extended horizontal or vertical drawings.

Ink pens are typically forgiving with regard to paper, with most working fine on almost any surface. Graphite is a bit more partial to a surface with at least a bit of texture, known as "tooth." You don't want the paper to be too rough, but if it's too smooth, the graphite won't adhere to the page very well.

Graphite Pencils

A basic #2 pencil is a fine place to start, though you'll eventually want to consider pencils with other levels of softness. Graphite is available in varying grades of density (soft versus hard) and in the amount of actual graphite contained in the core (dark versus light). The softer side of the range is designated with the letter "B" and a number from 1 to 9 (with 9 being softest) and the harder end of the spectrum has the letter "H" and a number from 1 to 9 (with 9 being hardest). So a "9H" is the hardest/lightest pencil available, and a "9B" is the softest/darkest option.

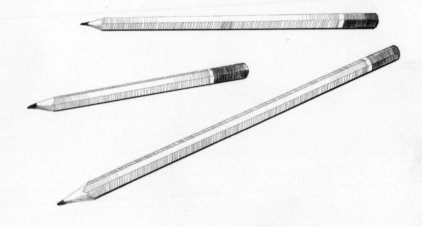

I typically work within a limited range of pencils, from about 2H to 4B. This so has helped me develop a sense of touch rather than being dependent on a wide range of drawing instruments. With practice, and by using a relatively soft and therefore responsive pencil (try a 2B), you should be able to achieve a complete range of values. In fact, in most drawings I only use one relatively hard pencil (2H) for the basic guidelines and one soft pencil (2B or 4B) for the shading.

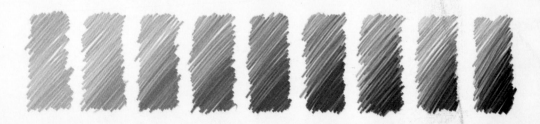

Pencil Accessories

To get the most from your pencils, it's worthwhile to purchase one or two extenders. These have a stainless steel cuff with a sliding grip that can hold what remains of a pencil that's been sharpened down to the extent that it's too short to hold comfortably.

For sharpening, an inexpensive portable sharpener will work just fine. I sometimes prefer to use a small pocket knife, though, because this tool makes it easier to whittle away more wood without breaking the tip, or to shape the tip in a way that helps me to achieve a broader stroke.

Tracing paper and drafting tape can be useful to protect graphite drawings that might otherwise become smudged from pages slipping against one another. Cut a few pieces to size and keep these in the back of your sketchbook, then use small pieces of drafting tape to secure a sheet of trace to the page (drafting tape is less sticky than masking tape, so it's less likely to damage the paper when it's peeled off).

Binder clips can be used to hold sketchbooks closed when you're not drawing (preventing pages from slipping against each other) or open when you are.

A glue stick can be used to affix museum tickets, receipts, and other mementos related to drawing subjects, which can make your sketchbook a richer repository for your experiences.

A small pencil case is handy to keep your sketching gear together in a portable package.

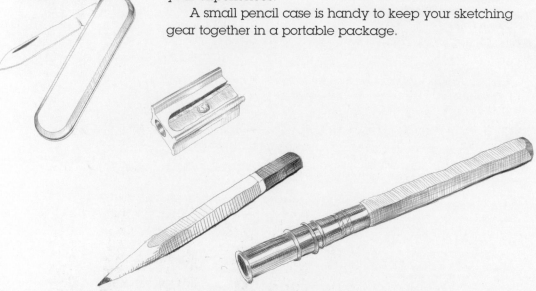

Erasers

The only reason I ever use an eraser is to clean up any smudges at the end of a drawing session. It's almost inevitable that you'll decide to carry one with you, but I strongly recommend against using it to erase any lines as you're drawing. Just keep your initial guidelines very light and don't worry about "mistakes"—by leaving an errant line on the page, you'll know better where its replacement will need to go.

Ink Pens

There are many types of pen available today, from the most basic, inexpensive, and disposable "ball-point" pen to the most precious and expensive fountain pen, and a dizzying number of options in between. Most stores that carry a good selection will provide small pads of paper for you to test line size and quality, so spend some time making scribbles with different types of pens as you shop. Look for a pen that gives a clean and consistent line, and get a few different sizes—a pen with a very thin line, one with a wider or heavier line, and perhaps something between these two.

Digital Drawing

With the increased availability of tablet and smartphone applications for drawing, these tools have become a desirable way for many people to incorporate drawing into their increasingly digitized lives. If digital drawing appeals to you, there are a few things to keep in mind. First, try to find a tablet and/or stylus that supports pressure sensitivity, such that increased pressure will create darker or stronger marks. Without this feature, your ability to create subtle shades and graded tones will be severely limited.

When you are drawing on a tablet device, avoid frequent zooming in and out, and instead try to settle on a particular size for the view that is a compromise between stroke dimension and overall drawing size. Also, resist the urge to zoom in too far, thinking that increasingly fine levels of detail will improve the drawing—this usually leads to the sense of getting lost in the drawing and adding far too much unnecessary detail.

Finally, the size of the digital device should strike a balance between portability and a reasonably sized screen—if the screen is too small it will greatly limit your ability to draw freely and to view the entire drawing while it's being created. Incidentally, many of the drawings in this book were created using Autodesk Sketchbook Pro software and a Lenovo Tablet PC.

FUNDAMENTAL DRAWING SKILLS

The ability to draw well has nothing to do with "talent." It is instead a completely learnable skill, and the more you devote yourself to mastering fundamental techniques, the more effortless drawing will seem, to both you and the people who see your finished works. The fundamentals of drawing are not complicated, but they might feel somewhat challenging or uncomfortable at first. With thoughtful practice and a good deal of repetition, however, the basic techniques will become second nature, allowing you to focus increasingly on more complex subjects.

Attitude and Posture

The most basic "technique" for drawing relates to your attitude—how you approach the process and what's really important to you. As you continue to make marks on the page, begin to consider what you're trying to do—most essentially, try to cultivate the understanding that drawing

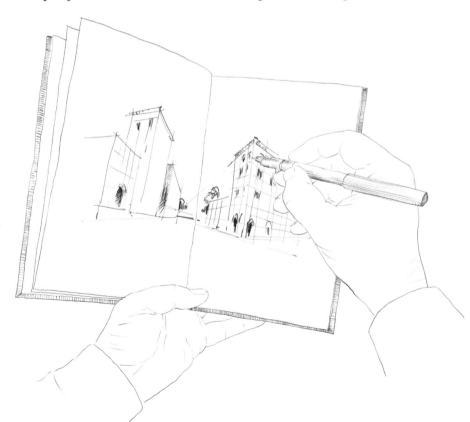

is more about a process than it is about a product. Let go of your expectations that any one drawing must achieve some arbitrary level of quality and instead learn to enjoy the simple acts of observing and drawing. If the process is engaged rigorously, thoughtfully, and repeatedly over an extended period of time, the resulting products will always be improving with regard to their perceived quality.

Do your best to be a good critic of your own development, rather than being "your own worst critic." This means that you care about the quality of your work, and you'll be honest with yourself about how you've succeeded and what needs additional work. But you'll also understand that not every drawing will be what you were hoping for, and take these bumps in your stride.

Posture

It might be assumed that you should draw in whatever position is most comfortable, but it's actually not quite so simple. While comfort is certainly important, there are other issues to keep in mind. One consideration is the amount of time you would like to spend drawing in a given session, another has to do with the way we perceive the urban spaces where we draw, and still another relates to the position of the sun. There is also the issue of how much—or how little—equipment you prefer to carry around with you.

I generally recommend trying to stand when you're out sketching, for several reasons. First, you'll be more free to really dial-in the best viewpoint for a given subject, and not be limited to places where there is convenient seating. Second, standing will usually force you to limit your time drawing—you'll be more likely to keep your drawings relatively brief and to the point, rather than getting too comfortable and spending too long trying to make the "perfect" drawing.

Standing while drawing also has the advantage of elevating your viewpoint to the height that most of us are at as we move through the urban space of the city. At the very least, I almost always stand while I'm setting up a drawing with light guidelines— then perhaps I'll sit somewhere within range of my original viewpoint to add value and complete the sketch.

Drawing on your feet might feel uncomfortable at first, but it does become easier with practice, and you can always use available props to your advantage.

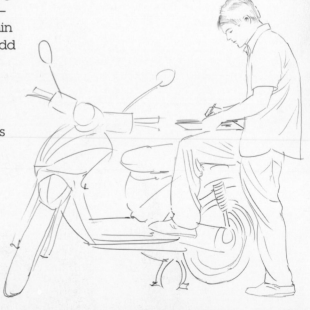

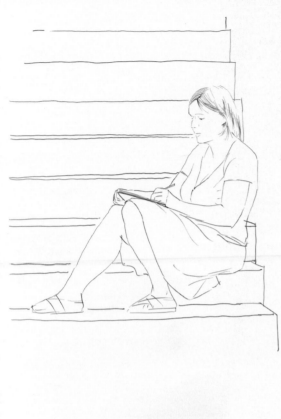

It's generally better to draw with the sun at your back so the light is on your subject. It also means the sun isn't shining in your eyes, which can quickly cause fatigue. In hot climates, it's usually best to find a shady spot from which you can see a well-lit subject, but still remain reasonably comfortable and not have the sun glaring off the page.

Stairs are a great place to sit while drawing—you can usually determine your eye level by moving up or down the staircase, and they often provide a good vantage point in piazzas and public squares.

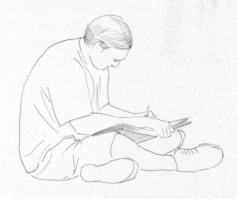

Many people like to carry folding stools, which allow them to sit just about anywhere comfortably. There are many types available, and some people even build their own.

Personally, I've never felt the need to carry the extra equipment—there are almost always some stairs or a low wall (or even the ground) if I really need to sit down.

Most often I tend to draw on my feet, and suggest that you give it a try at least several times before deciding that sitting is the best or only posture to adopt when you're drawing.

Seeing and Observing

There is a difference between "seeing" as it relates to our everyday experience and "observing" for the purpose of drawing. The difference has to do with how we perceive the underlying structure of a scene, and being able to translate what you observe into something that can be drawn in a relatively brief amount of time.

"Seeing" is a word we use frequently to refer to the act of using one's eyes, while "observing" might be a more appropriate word to refer to the act of preparing to draw, or what you do when you're trying to draw. "Seeing" suggests that you're taking in everything—all of the visual input your eyes can receive at any given moment—without very much in the way of discrimination. "Observing," on the other hand, has a stronger connotation toward being thoughtful and critical about visual information—certain elements of your view are receiving more or less scrutiny than others.

Stripping away extraneous visual information as a means to finding the essential structure of a view is a fundamental aspect of drawing. At the very least it allows us to complete a drawing in a reasonable amount of time, because we're not compelled to draw every single aspect of what we see.

Do your best to develop your ability to find the essentials of everything you draw—what is necessary to convey your interest in a given subject, and what is not. With practice, your skills for critical observation will contribute greatly to your ability to draw—you'll be able to size up potential subjects more effectively and then draw them more quickly and meaningfully.

The Brain and the Eyes

The single most significant impediment to drawing from observation is, paradoxically perhaps, the way our mind analyzes and interprets what we see. I first learned about this from Professor Francis D.K. Ching, who has been studying and writing about drawing for many years. In our daily lives, everything we observe is interpreted based on our past experience and our objective understandings of the objects and spaces we encounter.

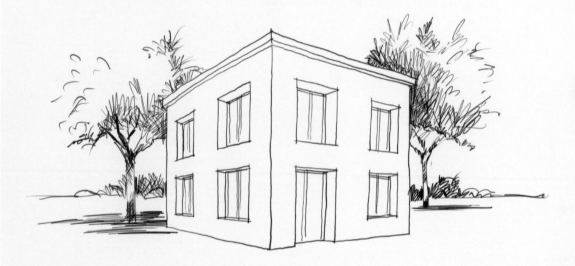

When we see a scene like that shown above, we automatically and subconsciously convert the visual input into more "useful" or objective information—approximate geometries, dimensions, distances, and so on. In my experience with students, this most often takes the form of a quasi-omniscient point of view, as though we are seeing things from above and in an abstracted manner, like the image at upper right on the facing page. Of course there's nothing wrong with how we analyze and interpret what we see. The only problem is that, when we try to draw, the result is some amalgamation of what we see and what our brain is telling us we're seeing, like the sketch at right.

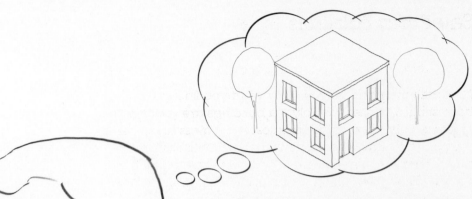

The solution is to learn to trust your eyes, and to use the techniques outlined in this book—measuring methods, basic perspective, and other compositional strategies. With practice you'll be able to translate what you see to the page with plenty of accuracy.

Selecting Subjects

It's most important that you draw what you find interesting. Whether crumbly old buildings are your thing, or you're only attracted to the latest shiny glass and steel skyscraper—draw what appeals to you. You'll have more motivation to draw frequently and more patience for the process of practicing than you would if your subjects are relatively uninteresting in your eyes. But if you only ever draw the same limited set of subjects, your skills might begin to stagnate, so try to challenge yourself occasionally and step outside your comfort zone by drawing subjects that you find less than completely compelling. At the very least, you'll be required to try some new techniques that might be more useful that you'd previously assumed.

When you're out looking for subjects—or even once you've found something you'd like to draw—move around before you begin. The same subject will appear different from a variety of angles, a point that is further discussed on the following pages, with regard to both point of view and proximity. But even slight movements on your part

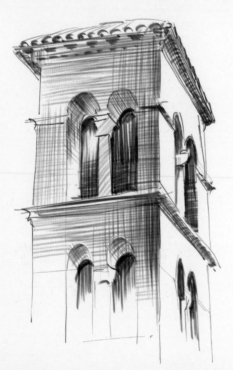 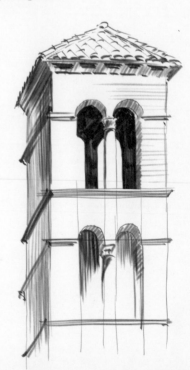

can affect what you see. I will often find a subject that interests me, and that I plan to draw, but then I'll really get specific about a precise angle from which to sketch. The bell tower on these pages is, to me, a fascinating subject from almost any angle. It's at the church of San Rufino in Rome, and in all the many times I've drawn it, I've spent at least a few minutes moving around and thinking of what would make the most interesting sketch on that particular day and at that particular time.

One of the most important reasons to move around before starting to draw relates to sunlight. As the Earth rotates and the Sun appears to arc across the sky, the light is always changing. If you draw a subject that's in shade, it's very difficult to convey depth and volume through the use of value contrast—the entire subject is likely to come across as dark and muddy, like the drawing below right. If you really want to draw a particular subject, but the light isn't quite right, consider the time of day and the cardinal directions (North, South, East, West), and make a mental note, because you might need to return to draw at a different time of day when the sunlight will be better.

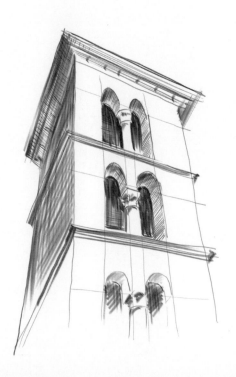
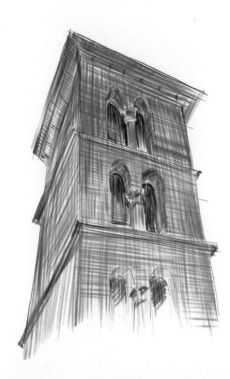

Point of View

It's very important to consider subjects from a variety of points of view before settling on the preferred position from which to draw. If you have ready access to an interesting drawing subject, try to approach it from a variety of angles and at different times during the day. Some factors to consider are the composition (a vertical or horizontal emphasis, for example), the particular lighting characteristics, the presence or absence of people, and the overall complexity of the view as it relates to the time you have available to draw.

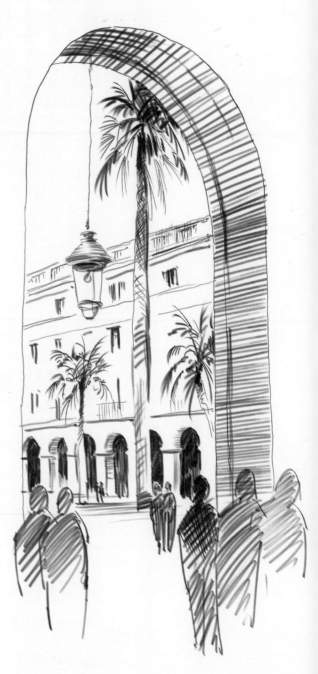

The two views shown here were sketched from the same position, but the results are quite different from one another simply because I turned my head. The drawing on the left looks out through one of the major archways surrounding a plaza in Barcelona. It emphasizes the vertical orientation of a single arch and the light and activity out in the square. The second drawing (below), is a one-point perspective that emphasizes the interior of the arcade and the play of light and shade.

In each case, certain elements have been accentuated or suppressed, based on what I thought would add or subtract from my impression of each view. For example, the capitals on each pilaster were of interest to me in the view below, while I decided to edit out the same detail in the drawing opposite.

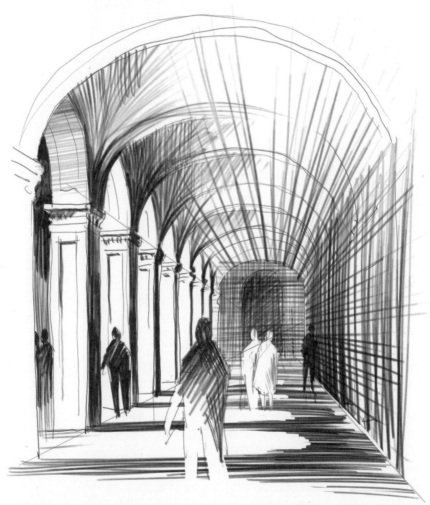

Proximity

An important aspect of selecting subjects for drawing is proximity—that is, the distance between you and the subject of the drawing. Proximity affects how much of a particular scene can be included in the drawing and the level of detail that can be achieved—both of which help determine what the drawing is really "about" in terms of scope, focus, texture, and so on. For example, all three of these drawings are of the Reptile House at the National Zoo in Washington, DC, but they begin to show the variety that can be achieved by varying one's proximity to the subject. In the drawing below, the central entry pavilion of the building is shown "in context." We see how the pavilion relates to the adjacent wings of the building, get some sense of the surrounding landscape, and begin to understand the size of the building as compared to the human figures in the foreground. It could be said that this drawing is about the pavilion as a whole, as we can understand its general size, shape, and volumetric characteristics rather than any particular details that went into its construction.

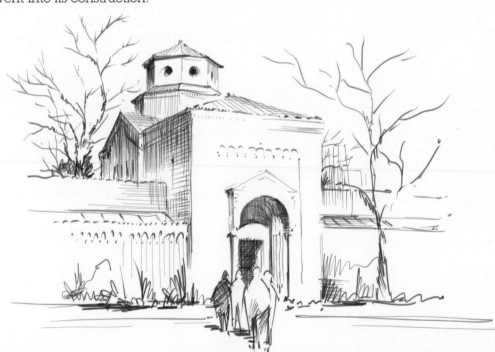

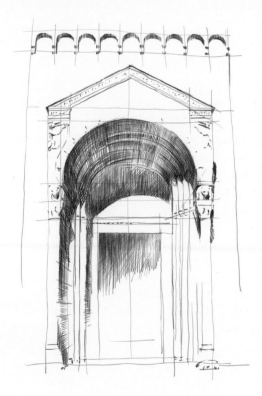

By standing closer to the entry and facing it on axis, we're able to focus on the porch surrounding the door. At this distance, the rest of the building becomes less important, and we can give greater attention to the geometry of the porch and begin to suggest some of the details that provide its special character.

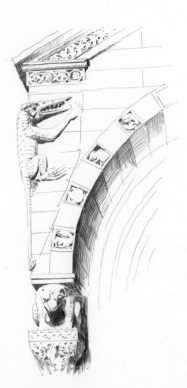

Getting even closer, some of the truly remarkable details become more apparent and more possible to draw with increased accuracy. In this case, the fantastical reptiles and amphibians that make up the corners and column capitals become the obvious focus—that is, what this drawing is about. It's often a good idea to combine a few drawings of the same subject—from varying distances—on the same sketchbook page, to give a more complete understanding of the building or other subject being drawn.

Measuring Methods

Sketching from observation isn't usually about achieving an extremely high degree of precision, but we'd typically like our drawings to be reasonably accurate depictions of what we see. Just a few easy techniques can help, but only if you make them part of your regular drawing routine. They'll require some practice and repetition before they begin to feel natural and you start to understand their value.

Sight Sizing

The simplest method, and the one most often overlooked, is called "sight sizing," and it's merely the act of holding your sketch right next to your subject in the distance. It's best if you move your sketchbook nearer or farther from your eye until the sketch and subject are as close as possible to being the same size. Then look carefully for mistakes in your drawing and try to correct them. This approach is best applied early and often—the more you catch big errors early in the process, the more easily and accurately the sketch will progress from there.

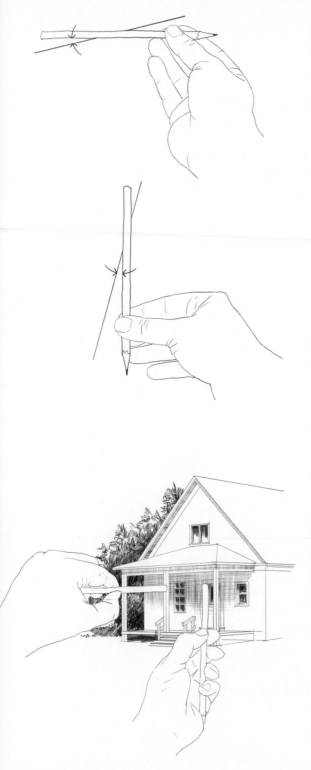

Sighting Angles

When trying to determine a particular angle in your view, you can use your pencil or pen as a baseline. Hold it horizontally or vertically, whichever is closer to the angle you're working on, and compare your pencil to the line in the distance. It helps to close one eye while doing this, so you can really compare one line to the other. If necessary, practice sketching the angle a couple times in the margin before adding it to your drawing, so that you'll be more certain to get it right. Use the sight-sizing method opposite to double check each angle as you add it to your drawing—especially for the major setup lines.

Sighting Proportions

Your pencil can also be used to measure relative sizes of elements in the view. Closing one eye, find one element (the space between the two columns, in this example) and compare it to another element (the height of the door). Look for situations where one element of the view is either equal to or some fraction (or multiple) of another, and use these proportional relationships to help establish the overall composition of the drawing. Note that it's important to hold the pencil the same distance from your eye during any related set of measurement.

Making Marks

Let's get started right away with some essential practice. You'll want to be skilled at making a wide variety of marks on the page, and it really helps to practice these skills repeatedly. In this way, you'll develop "muscle memory," meaning you won't need to think about it every time you need to make a particular set of marks, and your hand will more naturally make the marks necessary for sketching. This will allow you to draw with consistency and greater speed, regardless of the particular challenges you encounter in a given drawing situation.

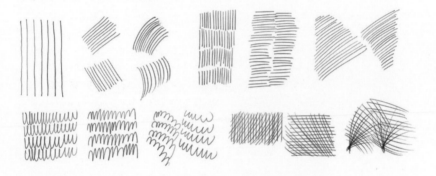

Start by making simple lines, trying to keep them reasonably straight, and mix it up with regard to speed. Make some sets of lines more slowly and deliberately, and others more swiftly. Notice the differences in the resulting lines—I find that the more swiftly I make the mark, the more smooth and clear is the result, but sometimes I might actually prefer a more wavering line. Also explore the variation possible between using the point of the pencil (above) versus the broad side (below), and experiment with varying pressure to achieve lighter or darker tones on the page.

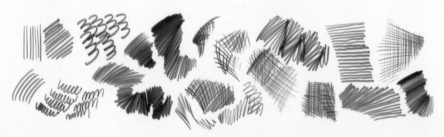

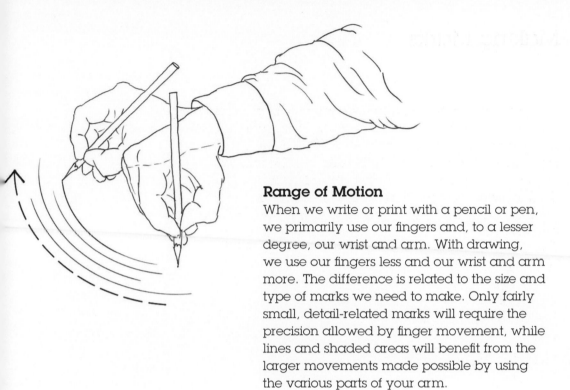

Range of Motion

When we write or print with a pencil or pen, we primarily use our fingers and, to a lesser degree, our wrist and arm. With drawing, we use our fingers less and our wrist and arm more. The difference is related to the size and type of marks we need to make. Only fairly small, detail-related marks will require the precision allowed by finger movement, while lines and shaded areas will benefit from the larger movements made possible by using the various parts of your arm.

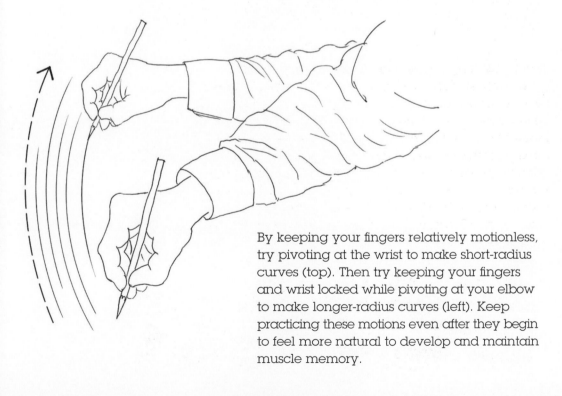

By keeping your fingers relatively motionless, try pivoting at the wrist to make short-radius curves (top). Then try keeping your fingers and wrist locked while pivoting at your elbow to make longer-radius curves (left). Keep practicing these motions even after they begin to feel more natural to develop and maintain muscle memory.

Lines

Making lines that are reasonably straight is an important skill to develop. Note that I've used the word "reasonably" rather than "perfectly." In freehand drawing, there's no need to make perfectly straight lines, or to be concerned about lines that waver. But you should be able to make lines that are straight enough to represent the edges and corners of buildings and other linear elements. Generally, the longer the line you'd like to make, the more you should try to use your entire arm in a smooth motion to move the pencil. It also helps to draw (or drag) the pencil across the page, with your hand leading the way and gliding on the surface, rather than pushing the tip of the pencil into the page. This has the added benefit of keeping the pencil pointed, particularly if you rotate it slightly as you go.

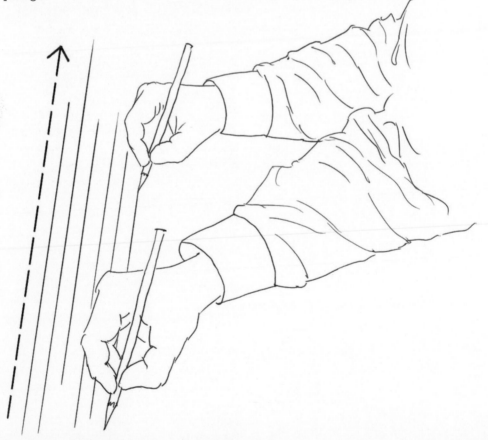

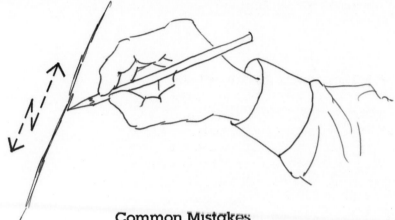

Common Mistakes

People will often make "sketchy" lines, as though moving the pencil rapidly back and forth is what they're supposed to do when "sketching." The result, however, is a fuzzy, indistinct line that leads to a fuzzy, indistinct drawing when every line is approached in this way. Strive instead to be decisive about where the line is going to go, and then draw it in a single, relatively swift motion. To do this well takes some practice, but the effect will be cleaner, less sloppy drawings.

Another mistake is to draw complete shapes in a continuous motion, especially with rectangular shapes (below left). It's far more effective to draw the lines individually, and to draw parallel lines in the same direction (below right), making sure that corners connect cleanly—even overlapping the corners slightly to create a definitive point where the lines meet one another. The result will be shapes that are clear and distinct, with lines that are more complete and straight.

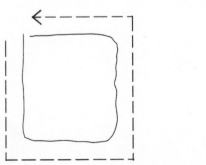

Hatching and Cross-Hatching

To develop consistent tone from lines, we use what are called "hatch" patterns. These are collections of parallel lines. To create uniform hatch patterns, the line lengths and the spaces between the lines should be as consistent as possible.

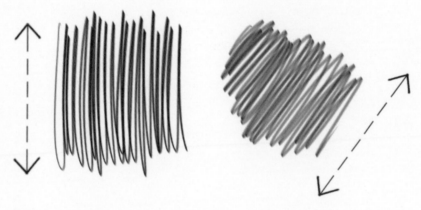

Avoid "scribbling" in both directions.

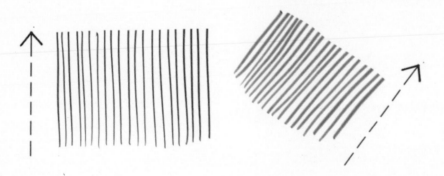

Instead, draw in the same direction, and strive for consistency.

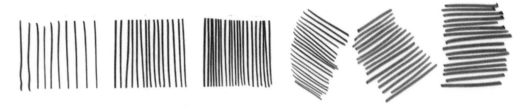

Experiment with various densities and orientations.

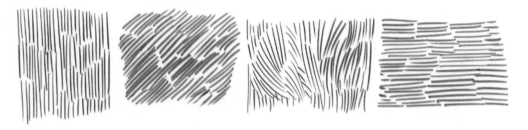

Build up larger areas of tone with grouped patterns.

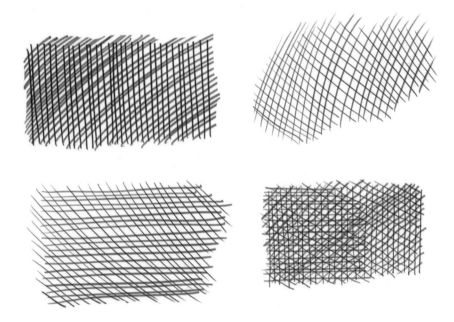

Create more density with crossing hatch patterns.

Graded Tones

While it's important to keep the value scheme of your drawings reasonably clear, there are often reasons to use graded tones. By "graded," we mean a tone that transitions gradually from one level of darkness to another—from a light tone to a dark one or vice versa. Pen and pencil require different techniques, because pen is a purely line-based, ink medium, while pencil is a dry medium.

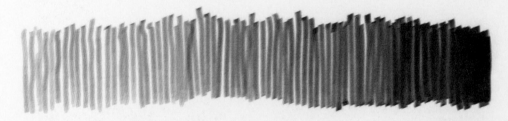

As you saw on the preceding pages, pen can require multiple passes to build up tone through cross-hatching. If we were to try graded tones using only a single hatch pattern, we'd be limited to adjusting the spacing between the lines or the line thickness (or both). But the vast majority of ink pens provide only a single line thickness, and adjusting the spacing doesn't give a very convincing graded tone—it just ends up looking like widely spaced lines rather than a uniform tone (right). So we'll need to build up the darkness and control the gradation by using cross-hatching (below). It can be a challenge to maintain consistency with so many layers of hatching, and it can be a time-consuming process to achieve the desired levels of darkness, but with practice you can develop both consistency and speed.

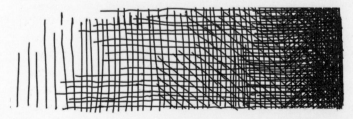

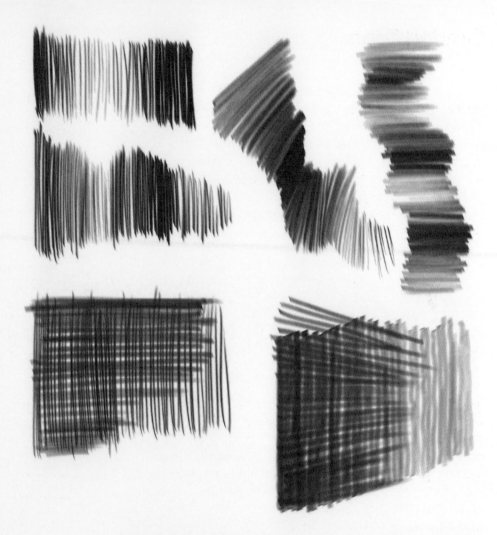

With pencil, we can use the broadside of the tip to achieve much wider marks with each stroke, and we can apply more or less pressure to adjust the relative values as we go (this versatility is one of the great advantages of graphite over pen and ink). It's usually best if you can apply the graded tone in one or two passes, rather than having to go over the area several times, but one or two additional layers of value applied as a cross hatch can greatly unify the tone. Practice making tones like the ones here—going from light to dark and back again—if only to develop a better sense of the varying pressure required to achieve smooth gradations. Learning to use fanning cross-hatch patterns (above, lower right) will be very useful as a way to reinforce the perspective of many architectural drawings.

Controlling Hatch Patterns

It can be difficult to keep hatch patterns consistent and, at the same time, keep them within boundaries on your drawing—especially if the patterns need to cover a relatively large area. The technique shown here can help, particularly with a good amount of practice over time.

Start with the pencil's tip at the most important edge (the leading edge of a shadow, for example), and make swift strokes away from this edge. You can let the end of the strokes tail off by releasing pressure at the tip, especially if it helps in keeping the repeated strokes consistent—this part of the technique requires the most practice. Make the strokes in whichever direction is most comfortable, rotating your sketchbook if necessary.

In this example, the first pattern (below left) is being made with swift strokes to the upper right. For the second pattern (below right), the strokes can be made in the same direction after the sketchbook has been rotated about a quarter turn clockwise.

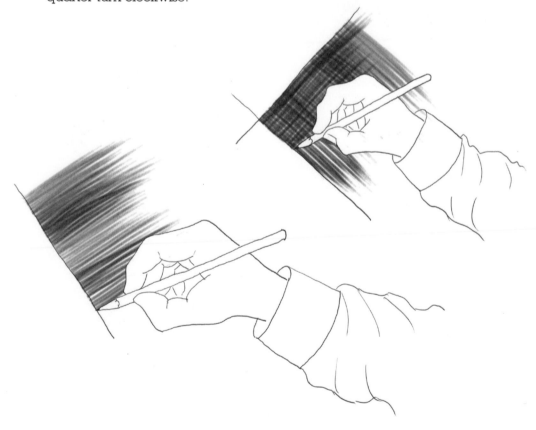

Strength of Contrast

The topic of value will be covered in greater depth later in the book, but don't be afraid to go "too dark" with your drawings. Quite often, beginners' drawings lack "punch" or drama, usually as a result of timidity when it comes to adding value. But the most effective way to create visual interest is to develop strong contrast between bright light and dark shadow, and it takes a strong and confident hand to apply enough darkness to overcome a weak drawing. Granted, these can be understood to be different approaches to the same subject—strong contrast versus more "subtle" contrast—and it's not as though one is right and the other wrong. However, it's generally a good idea to practice pushing your drawings farther than you think they can go with regard to contrast, if only to develop a sense of how to create drama and intensity in your work.

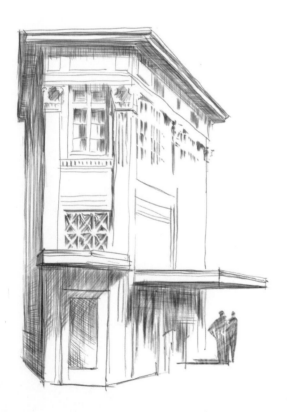
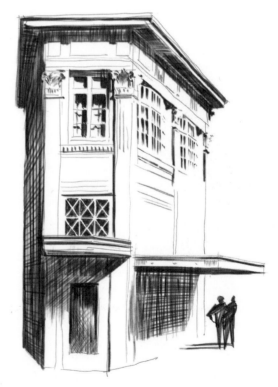

BEGINNING THE DRAWING

Perhaps the most common question I hear as a drawing teacher is, "where should I start?" As with many artistic pursuits, the answer could be, "start anywhere and see how it goes," but you're far more likely to feel a sense of accomplishment if you begin the process with some sort of plan regarding where and how to begin, and also how and when to finish.

At the most general level, I recommend a simple two-step process—making a reasonably complete "setup" sketch using light guidelines, followed by the addition of value (by drawing the darks and preserving the lights), with any development of detail being best approached as part of the value step.

Your first marks and lines are the most crucial elements in any drawing, though, as they will determine whether things go well or poorly for the duration. While it takes some patience and foresight to stick to this method, eventually the process will become easier and completed more swiftly.

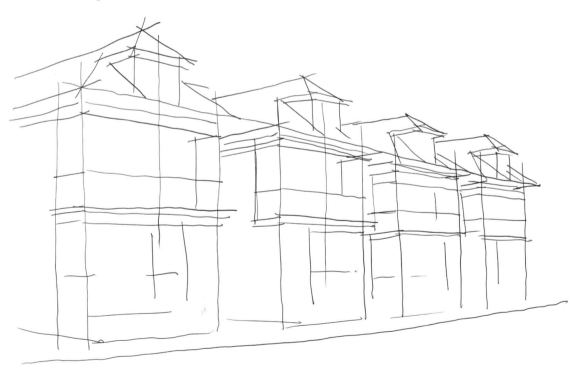

Time, Scope, Size, and Medium

There is a variable relationship among the following factors: the amount of time you have to draw, the scope of the subject, the size of the drawing, and the tools you use to draw. The decisions you make about each of these factors should have some impact on the others.

With regard to time, for example, if you only have 15 minutes to sketch, it will affect what you'll be able to draw in terms of the subject matter and scope, the size of the drawing, and the medium you use. You'll be limited with regard to what you're able to accomplish in the available amount of time, and if your decisions about what to draw don't fit the allotted time, it's very likely to be a frustrating experience. If you have more time, you can spend it developing a more careful drawing with a fair amount of detail, such as the example being developed on these two pages.

The "scope" of the subject refers to how much or how little of a view you decide to include in your drawing. It can range from a wide-angle view of a cityscape at the

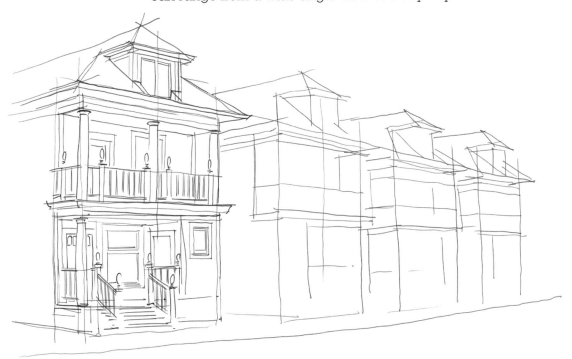

most ambitious end of the spectrum all the way down to a drawing of a simple detail such as a single window. The amount of detail you invest at either end of this spectrum will directly impact the amount of time the drawing takes to complete, and the size of the drawing will affect how much detail you're able to show in any case. In other words, a large scope in a small drawing will require a good amount of abstraction (like the example seen here), and vice versa.

With regard to media choices, graphite is usually the most versatile and quickest, while pen or marker are typically less versatile and take longer to build up the necessary amount of hatching for value. Watercolor usually takes the most time, unless it's used for a simple splash of color on a drawing that was first created with graphite or ink.

In the example shown here, the amount of time you have available for your drawing session should help determine what you decide to draw—all four houses, only one or two, or just a small portion of one? But the size of the drawing must be considered as well—perhaps a small drawing of all four houses could be achieved in a short time by drastically limiting the detail? These considerations might only require a minute or two of your time, and they should precede all of your drawings so that you're clear on what you're about to begin, how large or small it will be, and how long it will take.

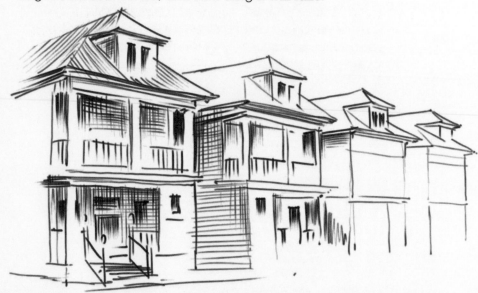

Page Layout

Along with the considerations already mentioned, it helps very much to think about the overall arrangement of drawings and text on the page. You might not include any significant amount of text—perhaps the place and date are all that's needed. But if you're hoping to include more than just one drawing on a page, and more than the most minimal amount of written information, you'll want to plan the layout of the whole spread (that is, two facing pages) before you get started. If you plan to have a group of images and at least some narrative text, it's also wise to plan for a unifying title for all of your efforts. While all the components of a unified page spread might be developed on the fly, it's best to rough out some space-holders until you can get around to each drawing or block of text. Simple shapes like ovals and rectangles will do the trick, and if you draw them using very light graphite they'll remain flexible enough to evolve as the page or spread is fleshed out.

Keep in mind also that sometimes drawings will want to overlap each other in a collage fashion, so the boundaries between them might be a bit fuzzy or in some cases nonexistent. Especially appropriate for this treatment would be drawings at a variety of scales and sizes, and specific subjects that all contribute to the same story or experience of a place. Small key maps are also excellent candidates for inclusion, as they help to set the broader context for your observational drawings.

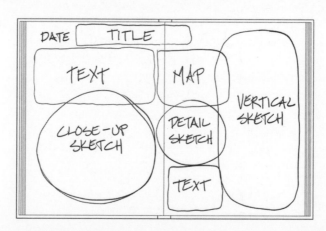

Initial Layout

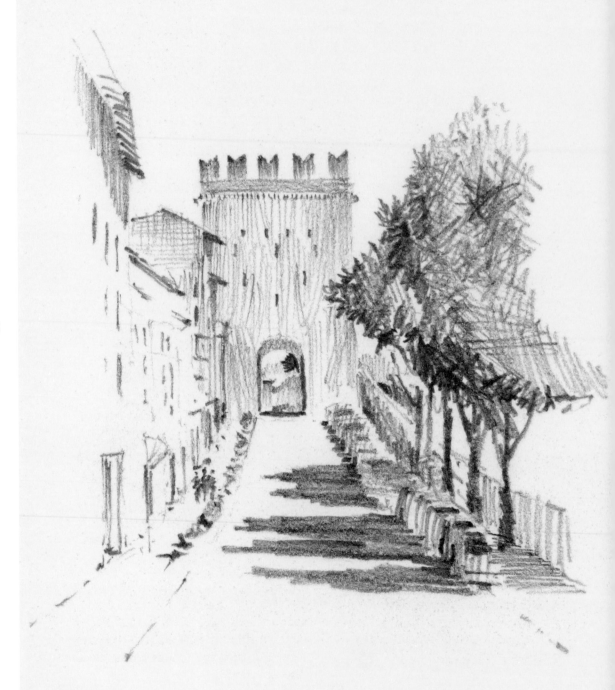

Establishing the Elements: Example 1

 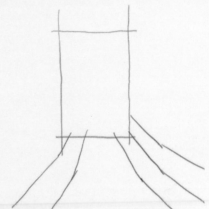

Start with the focal point: In this scene, from the Italian hill town of Assisi, the simple rectangular shape of the city gate is the first drawing element to be established, using very light lines.

Outline the foreground: Next, the basic outlines of the road and sidewalks determine the shape and extent of the foreground.

Balance the elements: Working from these guidelines, incrementally smaller elements of the drawing are added in a balanced way, without giving too much attention to any particular area.

Add detail: When the overall structure of the drawing has been established, the "initial layout" is complete. At this point, value and some detail may be added to create contrast and depth, thus finishing the drawing.

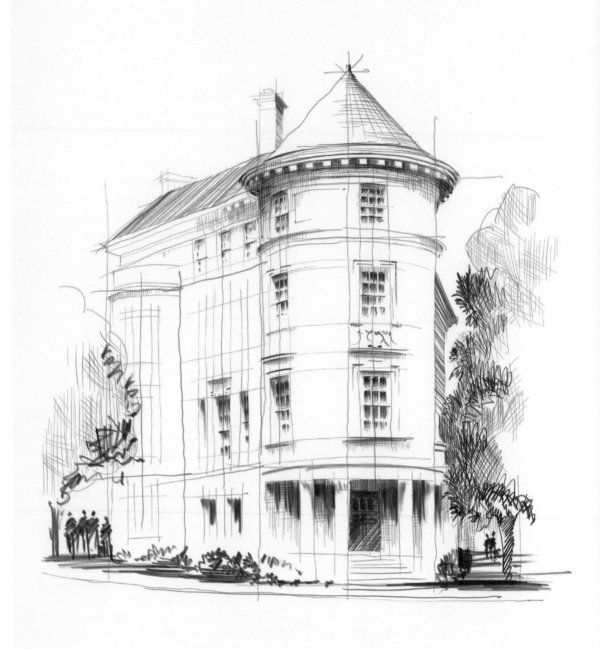

Establishing the Elements: Example 2

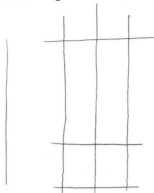

Start with the most basic shape: This grand old house on Embassy Row in Washington, DC, has an interesting circular corner tower. Start by drawing simple rectangular shapes that locate the major elements—don't worry about the curves yet.

Move to the next level: Using your first lines as a guide, and the measuring methods discussed on pages 30–31, arrange a few of the major angles of the view. With each step, start moving to the smaller elements, giving yourself small marks to identify locations.

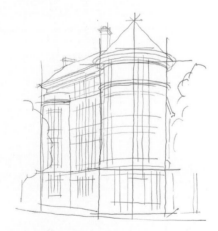

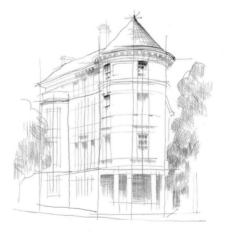

Continue the process: With the overall guidelines mapped out, start developing smaller scale elements such as windows. This is also the best time to map out the lines of the street and outlines of any landscape elements.

Add value: Once you're confident that you have enough line work to serve as a guide, start to apply value (and therefore light and depth) to the drawing. Avoid getting too particular about little details, though.

Composition

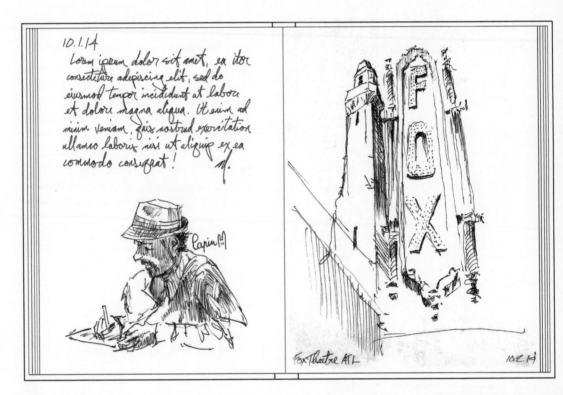

10.1.14

Lorem ipsum dolor sit amet, ea itor consectetur adipiscing elit, sed do eiusmod tempor incididunt ut labore et dolore magna aliqua. Ut enim ad minim veniam, quis nostrud exercitation ullamco laboris nisi ut aliquip ex ea commodo consequat!

Fox Theatre ATL

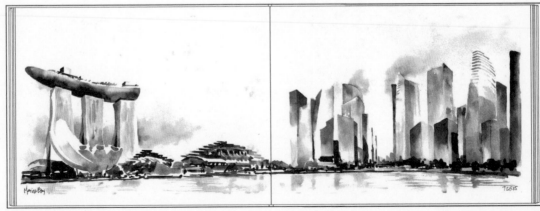

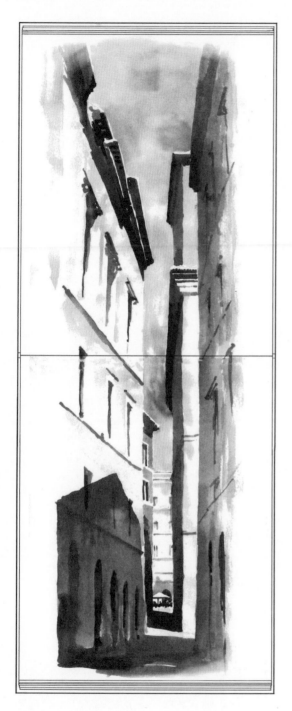

Before starting a drawing, it helps to consider what might be the most natural organization of a particular subject. While it might seem that the majority of subjects can simply be placed on the page, some suggest (if not require) a different approach, or even a particular type of sketchbook that allows something other than the ordinary portrait orientation.

For example, some subjects are best drawn as a vertical composition, such as this street scene in Rome (left), while others will benefit from a horizontal orientation, such the broad view of Marina Bay in Singapore at the bottom of the page opposite. You may also want to think about space for text, whether it's personal notes or just the name of the place and the date of the drawing (opposite center).

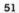

As a way to arrange the major elements on the page, "composition" is the act of taking one element at a time and placing it with respect to a two-dimensional frame or organizing grid. You can use the edges of the sketchbook page as a frame, or you can draw a rectangle on the page and work within these boundaries. In either case, it's helpful to first visualize a frame around the subject by using a "viewfinder"—a piece of thick paper with a rectangular window cut out of it. You might create a few of these to carry in your sketchbook, each with a different set of proportions and with marks that divide each edge of the window into halves, quarters, and thirds.

The viewfinder can be used to determine how much of a particular subject will be drawn, and what the best orientation might be. Beyond these uses, the viewfinder can be used to locate major drawing elements within the frame (including their size, angle, and orientation), and then to help transfer these observations to the page. It should be obvious that each time you look through the viewfinder you need to hold it in the same place, so your references are consistent.

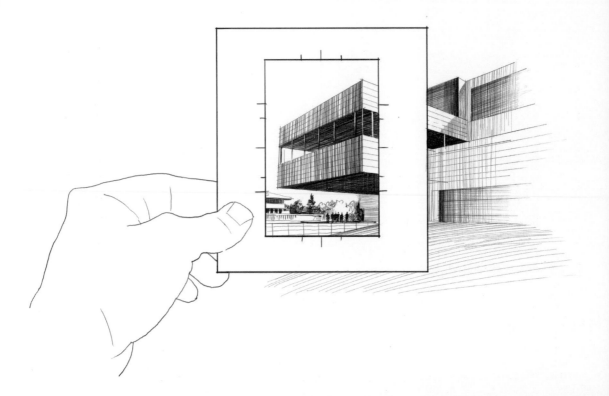

Draw a simple frame that corresponds to the proportions of your viewfinder (below). While the frame you draw doesn't need to be the same size as the frame in your viewfinder, it does need to be the same proportion—2 units wide by 3 units tall, or 2 units by 4 units, and so on.

Just having a frame like this on the page to work within can be enough to help you lay out the drawing, but it can also be helpful to add some grid lines that correspond to the marks on your viewfinder (below left), dividing the frame into quarters or thirds, for example.

Then, begin placing the major layout lines according to where they appear in relation to the viewfinder. In this example, notice how the line of the window sill crosses the very center of the frame—and how this location is clearly marked by the grid lines that cross at the center. These frame and grid lines can be extremely helpful as the major elements are arranged on the page.

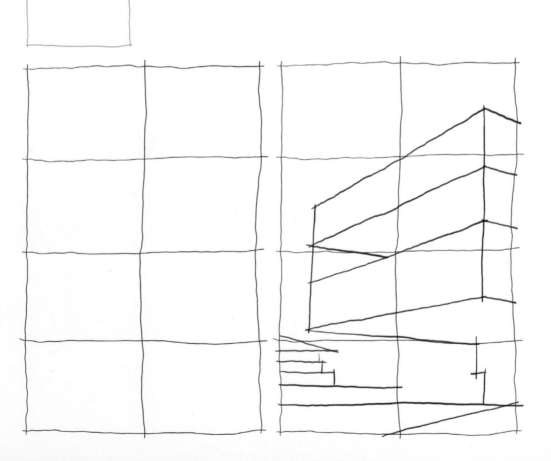

Perspective

Too often, the mere thought of perspective can instill
a sense of fear in the beginning sketcher, because the
subject is usually treated with too much complexity,
or because it is assumed that a comprehensive
understanding is necessary before one can use
perspective to aid in the process of drawing.

The complete science of perspective is indeed fairly
complex, and many excellent books cover the subject
in detail. But for the purpose of drawing from direct
observation, it's not necessary to have a very deep
knowledge of every rule and technique. If you use the
basics of composition as the primary means of laying
out your drawings, then some limited knowledge of
perspective can only help. These pages are intended
to get you started with the most fundamental elements
of perspective drawing, rather than attempt to cover
the subject exhaustively.

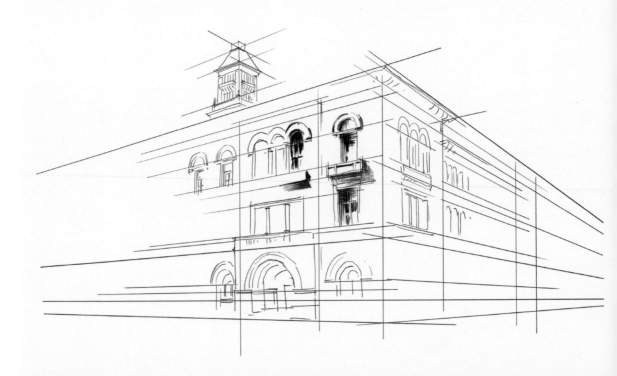

Diminution

The most essential idea regarding perspective is that objects appear to diminish in size as their distance from the observer increases—in other words, the farther away something is from your point of view, the smaller it will appear to your eye. The lamp posts and wall shown here provide a simple example. The diagrammatic sketch below left shows that the lamp posts are all the same height, and the height of the wall and its openings are consistent along the entire length.

However, when viewed in perspective—that is, from the point of view of the human figure (below right)—these objects appear to be reduced in size as their distance from the viewer increases. It's quite a simple phenomenon once you understand it, but this rule (technically referred to as "diminution") determines how objects and spaces will appear in perspective.

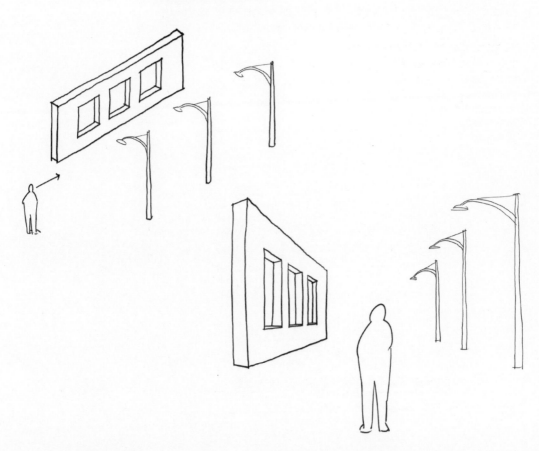

Convergence

The next most critical element of understanding perspective has to do with the way certain sets of lines appear to run toward each other when viewed from an angle. Groups of lines that are parallel to one another in space will appear to meet at the same point in the distance, a visual phenomenon known as "convergence."

This is reasonably clear with the wall shown here, and the tops and bottoms of the windows, because these are defined by a group of horizontal lines that are parallel to one another in space.

It's a bit less clear with the lamp posts, but the points at which these posts meet the ground, their tops, and the lamps themselves define an invisible set of lines in space, illustrated by the dashed lines running through the points.

It's important that you begin to see these lines of convergence in the architecture and other objects you're trying to draw, and that you use guidelines to define them on the page. Otherwise, elements of the view such as these lamp posts will likely be misaligned at the outset of the drawing.

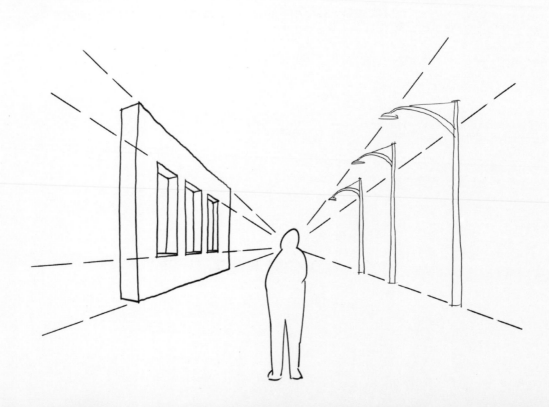

Eye Level and the Horizon Line

The height of your eyes at any given time, known as your "eye level," helps determine how objects will appear from your point of view, and can be understood as an invisible, horizontal plane that intersects your eyes and extends outward before you. When we extend this plane to its greatest visible distance it becomes what we call the "horizon line." This is where all lines that are horizontal in space will appear to converge—every set of parallel, horizontal lines will have its vanishing point on the horizon line. Think of it as the line along which the earth or the sea meets the sky, assuming there's nothing to obscure the view—most of us have seen the horizon line when we've stood on a beach and looked toward the ocean.

In most drawing situations, however, the horizon line is not so clearly visible, although it's always there as an imaginary line at the greatest extension of our eye level. So the two terms (eye level and horizon line) mean almost the same thing, as they are so directly related to one another; I usually think of the latter as an extension of the former. With drawing, it can be very helpful to identify where the horizon line will be (related to the subject and also your drawing), and to build the sketch from this line.

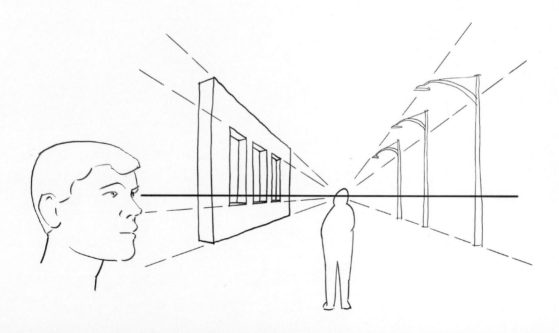

Multiple Vanishing Points

There are common expressions for a few types of
perspective drawings—"one-point," "two-point," and
"three-point"—that refer to the number of vanishing points
that determine how converging lines are arranged in the
view. The drawings on the preceding pages would be
considered "one-point perspectives" because they are
based almost entirely on a single vanishing point, with
all the spatially horizontal lines converging on that point.
The distinctions among these types of perspective can be
useful, especially when drawing perspective views from
your imagination—constructing views of a design project
that has yet to be built, for example.

In reality, there are almost always going to be multiple
vanishing points in a typical view. Take this simple
drawing of a stair (below). The lines that are horizontal in
space—the nose of each stair, and where the top of each
stair meets the side of the staircase—will appear to
converge on vanishing points on the horizon line, one
point to the left and one to the right. However, because
the sides of the staircase are not horizontal in space, and
are instead sloping, they will appear to converge on a
point well above the horizon line. So, even in this simple
drawing, there are actually three vanishing points.

Once you have established the horizon line and one
or two of the lines of convergence, the vanishing points
can be used to draw additional converging lines with
greater accuracy.

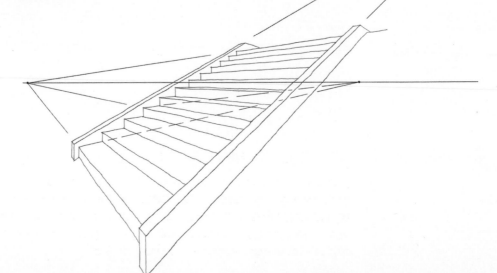

Applying Basic Perspective

I almost always use simple composition techniques to get a drawing started, but some very basic approaches to perspective can move things along while also ensuring a good amount of accuracy.

Start by establishing the horizon line, remembering that it will be at the same level as your eyes. In this case, the horizon line is about 6 feet (1.8m) above where the building meets the ground (my eye level as the viewer).

Then, establish one or more of the major angled lines in the view—the top left and top right lines of the building. By carrying these lines all the way to the horizon line, we find the left and right vanishing points.

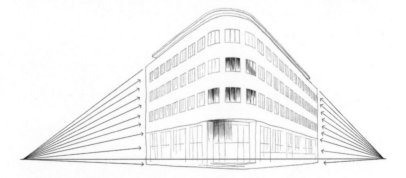

Using the vanishing points as the start of additional guidelines, draw the tops and bottoms of aligned windows, doors, and so on. Complete the setup drawing by adding vertical lines as you go, then finish the drawing with value and entourage (see page 92 onward to read about entourage)—a process I've just started here.

COMMON CHALLENGES AND STRATEGIES

Every new drawing subject presents its own set of challenges, and this is one of the primary reasons I continue to draw—it simply never gets old. But there are numerous situations that tend to crop up repeatedly from one drawing to another.

Odd geometries and curvilinear elements are quite common, but very challenging to draw with a reasonable level of accuracy. Good examples are visible in several places in this sketch of Old St. Patrick's church in Chicago. It's always a good strategy to work out specific problems in the margins of your sketchbook, as I've done here at lower right. Make as many partial drawings, at a slightly larger scale, as you find necessary to understand the basic structure of any unusually challenging elements before working these into the overall drawing.

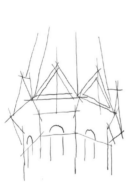

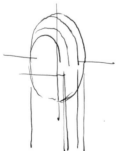

Structure and Value

While you should always develop a drawing's underlying structure thoroughly in light lines before adding value, try to keep from going overboard with the setup lines. It's during the initial setup that you'll work out the problems mentioned on the previous page, but knowing when enough is enough as a guide is a challenge in itself.

The key is to avoid trying to draw every little detail you see, because detail is usually only appropriate when you're drawing at a fairly large scale and at close range. You'll want just enough information to give you a clear understanding of where the value will go, and the value often ends up obscuring the finer details.

So be economical when laying things out, but generous with lines that will help you solve the types of problems mentioned on the previous page. This drawing is partially completed to give a sense of how much (or how little) I typically draw before jumping into value to complete the drawing.

Alignment of Windows

Windows are most often aligned with one another in columns and rows, or at least there is some geometric relationship between them that should be used to your advantage in drawing.

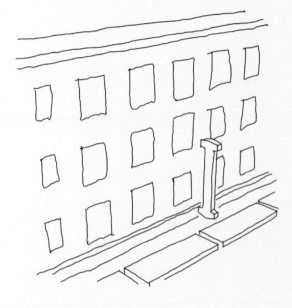

Guidelines: Drawing each window individually, one at a time, will almost certainly weaken their alignment as a group (upper right). It's always better to start by drawing a series of light guidelines that stretch across the tops, bottoms, and sides of as many windows as possible, forming a grid as seen in this image. If the guidelines are very lightly drawn, they will be less apparent in the finished drawing, once shading is applied.

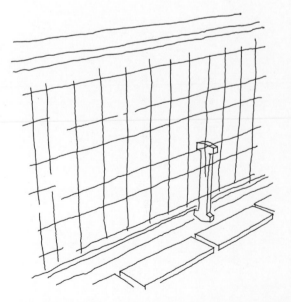

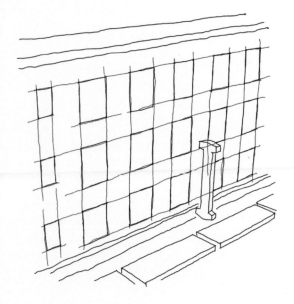

Using the grid: By establishing an overall grid of guidelines, the windows will be positioned more accurately and they will come into much better alignment with one another. With a well-established grid, drawing window outlines is seldom necessary. They are only shown here to emphasize the improved alignment as compared to drawing windows one by one.

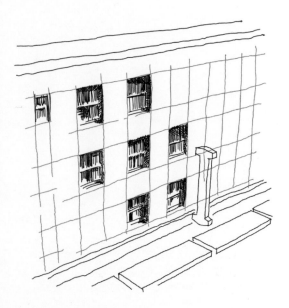

Add detail: With the gridlines in place, windows can be developed through the addition of shading and hatching. As the drawing nears completion, the grid will recede to the background, paling in comparison to the darker shadows and detail elements.

Non-Linear Elements

It's generally an easier process to draw linear elements in a view—the lines that are clearly straight. They may be at angles that are challenging to capture, but the techniques of composition and perspective can most often assist in getting them down on the page with reasonable accuracy. Curves, on the other hand—circles, ellipses, and the like—are more difficult, but there are some basic strategies that can make the process more manageable.

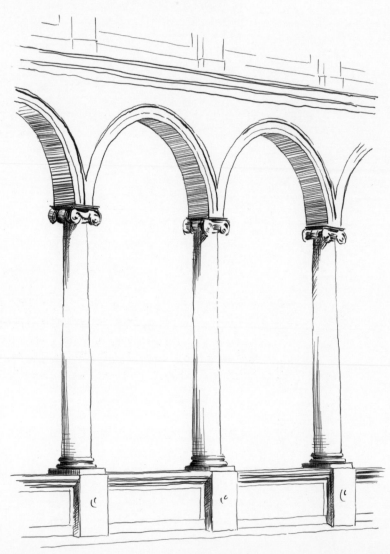

It's usually a good idea to begin with lines or other shapes to get the general forms into position, and then complete the curvilinear form by filling in between points. To draw a circle, for example, start by drawing a square, and then draw diagonals that connect the corners.

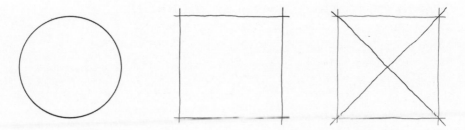

The diagonal lines will cross at the center of the square, which allows us to draw a vertical line and a horizontal line that subdivides the square into quadrants. If we measure the distance from the center with our pencil, along one of the vertical or horizontal lines, we can find the radius and transfer this measurement to the diagonals.

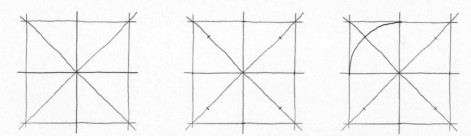

Then, draw an arc that connects these points, one quadrant at a time. If it helps, additional diagonal radii may be inserted to provide additional points before drawing each arc. Follow this process to complete the circle, or as much of it as is needed in your drawing.

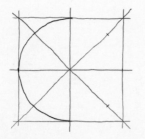
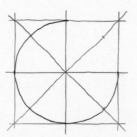
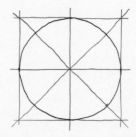

Ellipses: When a circular form is seen in perspective—that is, when it's being viewed at an angle, rather than straight-on—it will appear as an ellipse. Unlike circles, ellipses don't have a consistent radius, but instead have one long axis and one short axis. It's still best to start with bounding lines, as shown here, but it will take some practice to draw elliptical curves.

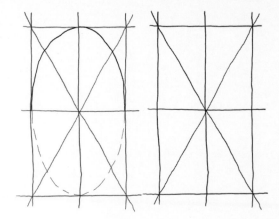

Arches: The practice of drawing ellipses really pays off when you're dealing with arches. Notice how the form of the ellipse is still clear, and is still constructed the same way as above. Also notice how the back side of each arch is also defined by an ellipse. Of course, the ellipses will get smaller as they become more distant in your view. If you're viewing the arches at a sharper angle, the columns would be closer together and the short axis of each ellipse would be shorter—making the ellipse narrower from side to side.

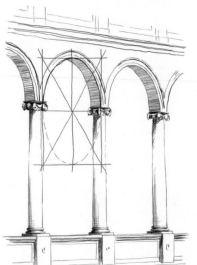

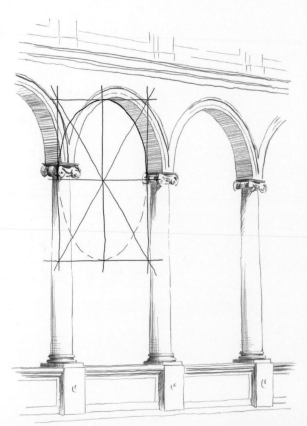

Horizontal ellipses: The same technique for constructing ellipses can be used whether they are oriented vertically or horizontally. As seen in the previous examples, when a circular form is oriented vertically in space, and we view it from an angle, it will appear as an ellipse with its long axis oriented vertically. When a circular form is laid flat (oriented horizontally in space), the long axis of the resulting ellipse will be oriented horizontally. When there are numerous circular forms in the view, there will be just as many ellipses in the drawing.

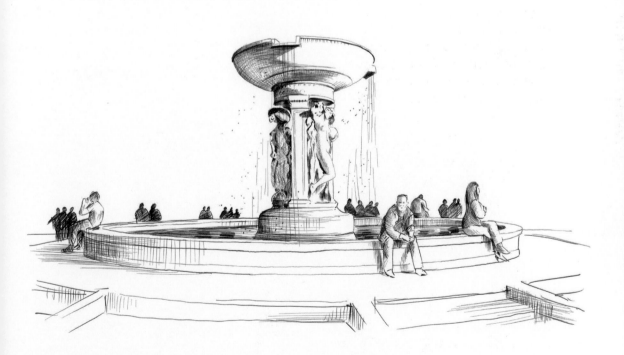

Reflections

Pools of water—or even wet pavement—will create
reflections that can add considerable interest to the
foreground of a drawing, which might otherwise be quite
empty. Try to understand how reflections will appear in a
structural sense. The vertical lines in the view will simply
appear to extend straight down into the reflection, while
the more challenging lines to understand are the angled
lines of convergence. These are merely an extension of
the perspective, with the reflected lines converging on the
same vanishing points as their counterparts in the view. In
this example, which is effectively a one-point perspective,
the converging lines of the wall on the right meet at the
vanishing point, on the horizon line. The horizon line and
its associated vanishing points are not reflected, but rather
serve as the source of the reflected lines of convergence.

Rendering Reflections

As with any drawing, it helps to apply hatching in a way that reinforces the lines of convergence in perspective. But water, and particularly water that isn't perfectly calm, will affect the consistency of the lines and other marks used to render light and shade. The edges between dark and light areas of the reflection will often be broken up slightly by the ripples of the water's surface. This will tend to increase as the reflection nears your position and becomes more distant from the objects being reflected. In this example, the shading closest to the building is a fairly accurate reflection, while the reflection of the roofline becomes more broken. When rendering this slightly choppy water, it's best to keep the pencil strokes horizontal, to represent the horizontal orientation of the uneven water surface.

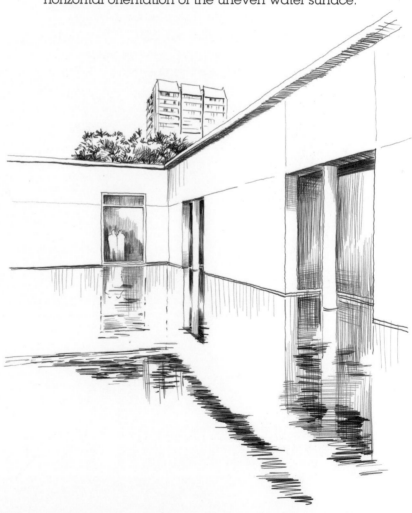

Calm Water

If the reflections are in still water, there will be very little difference between the way the view and its reflection are rendered—one is effectively a mirror image of the other. It can often help to develop the drawing somewhat, and then turn your sketchbook 90 degrees in one direction or the other. This allows you to see the objects in the view and their reflected image side by side, making it easier to see the direct similarity between the two. Try to mirror the hatch patterns and landscape elements to really reinforce the mirrored effect.

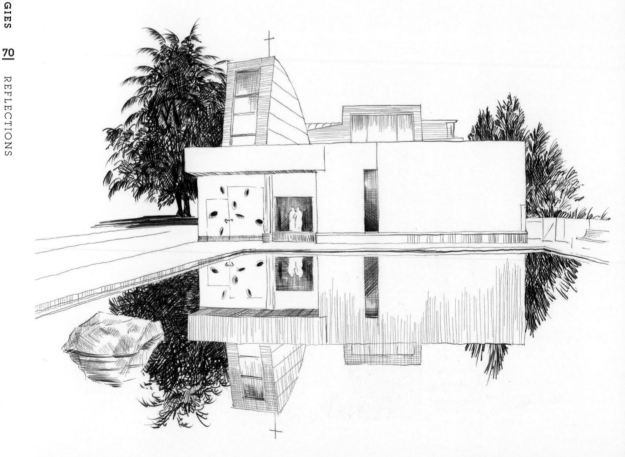

Reflections in Cityscapes

Modern glass buildings can be a bit tedious to draw, but they often reflect adjacent buildings in their facades. There's no need to be overly precise, as these reflections are usually a bit inconsistent based on the imperfections in the glass facade—the reflections frequently appear quite wavy or even a bit random. There is often a shift between the structure and the glass, depending on whether the building being reflected is in sun or shade. When it's in shade, it will be likely that the structure of the glass (the mullions) will be light, and when the reflected building is in sun, the mullions will typically be seen as dark. Using reflections like this is an excellent way to break up an otherwise monotonous facade—another example can be found on page 74.

Developing Interest in Repeating Elements

There are often elements of buildings that appear repeatedly—windows, in particular. After establishing the overall layout of the drawing by outlining the major elements in a light hand (upper right), it's time to add shading and depth.

A common problem arises when repeated elements are handled in a very uniform manner—using the same hatch pattern, for example (right). This has the effect of creating a rather flat and monotonous rendering of the subject, and doesn't begin to suggest the differing levels of light and depth that are most often seen in groups of windows, doors, or other elements.

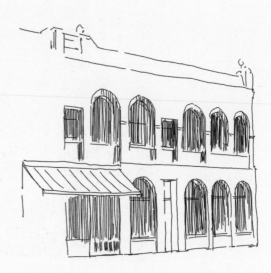

A better strategy is to strive for variation in the way shading and detail are applied—even if there isn't so much dramatic variation visible in the subject. Changing the directions and densities of the hatch patterns is a good way to begin this approach. Observe how reflections—of sky, trees, or adjacent buildings—tend to create variable patterns within each window, and how shades or drapes on the interior will make some windows much lighter than others. Be bold in drawing the alternating contrasts, and have some fun with the process of making the image sparkle and vibrate.

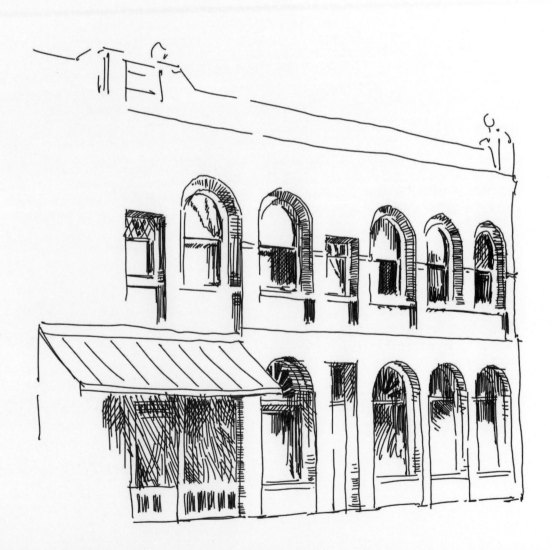

Glass and Steel

Even sleek modern buildings will benefit from variation, especially if it's based on careful observation of the building's reflectivity. At close range, and if you're looking at the shaded side of a building, you'll most likely see some blinds or drapes, but beyond that the interior will almost always appear to be very dark. When viewing a glass building from an oblique angle, especially if your line of sight is aimed upward toward the sky, you'll see almost nothing—only the seams of the building's exterior will cast very fine-lined shadows. Between these two extremes—close up and oblique toward the sky—it's very common to see other buildings reflected in the facade.

Being Selective

When you're faced with an interesting building, but the wealth of detail or repetition of windows seems too daunting to attempt a sketch, being selective about what you draw can be an excellent strategy. After laying out the entire subject in light lines, decide what aspects of the subject you find most interesting, or what parts of the building say the most about its character. Then do your best to add only enough additional information—usually in the form of varied value on the windows and other details—to provide some suggestion of three-dimensionality. Try to avoid getting locked into drawing everything with the same level of attention, and the viewer's eye will complete the scene.

LIGHT AND SHADE

Reserving Light

In direct combination, light and shade in a drawing make it easier for the viewer to understand three dimensions, depth, and the turn of one surface to another along corners and other building edges. Rather than seeing lines that define these edges, a more powerful and clear image can be made by defining edges as changes in light.

To produce the clearest contrast in your drawings, it's very important to reserve light on the page. Too often, there's an impulse to cover every square centimeter of the page with marks. If we were to follow this impulse to draw everything we see—every brick or stone or shingle on a building—we would significantly diminish the opportunity to show light. This is especially true when using a monochromatic medium such as graphite or ink, as opposed to colored pencils, markers, or watercolor.

The logic of the light needs to be consistent—such that it's clear where the sun and resulting shade are located—but within those parameters, you should be free to show the light/shade in a way that brings some emphasis to certain parts of the drawing, and perhaps less to others.

In this example of a Victorian Gothic building in Portland, OR, the area at the base is drawn loosely, but with strong darks, to represent the dappled shade from the trees. The upper portion of the building is more controlled and crisp, to represent the intensity of the sun and its effect on the complex architectural elements of the facade.

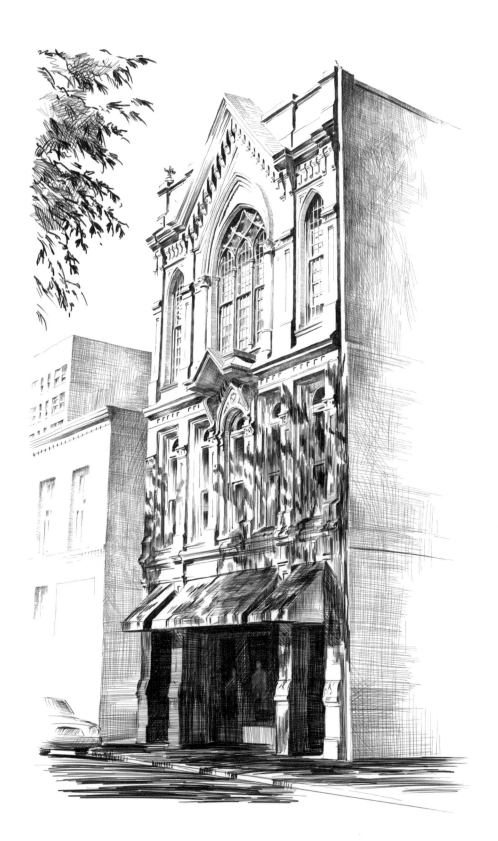

Developing Contrast

The process of adding value to a drawing can take some time, but the result is well worth the effort. If you get in the habit of planning what you're going to do before starting, you'll be more efficient with your time. In this series of images you'll see how I work in layers of value to develop contrast in a methodical way. Always keep in mind that the main area of focus should have a greater amount of contrast, which means that the darks should be darker and more crisp than in other parts of the drawing.

 The first step is to create a reasonably thorough line drawing of the subject—one that's not too heavy on detail but that identifies the various surfaces to be rendered. As part of this step I usually give myself at least a few lines that will define the edges of the shadows, so when the sun changes position I'll have guidelines that show the shadows where they were when the subject first caught my eye.

Begin layering the value, from the lightest tones to the darkest. Try to work with one level of tone at a time, and do your best to be consistent with the hatch patterns. In this step, I'm working only on the tones that are just a shade darker than the parts of the subject that are in full sun. I typically begin with vertical hatch patterns, concentrating on the vertical surfaces.

Try not to jump ahead too much, and add any of the darkest darks at this stage. If you know that there will be darker parts of a particular area, that's fine—just make one pass with a consistent vertical hatch, knowing that you'll be adding more layers of darkness as you go.

Create additional layers of hatching, but in opposing directions—either horizontal patterns or as directional patterns that follow the lines of perspective. The areas that are only as dark as the previous pass of hatching can be left alone, but the next level of darkness can be developed at this stage with an eye toward developing the central focus of the drawing. You can also make additional passes with hatch patterns in the same direction as those that came before, to add greater density (and therefore greater darkness) or to clean up any rough edges of the preceding hatch patterns.

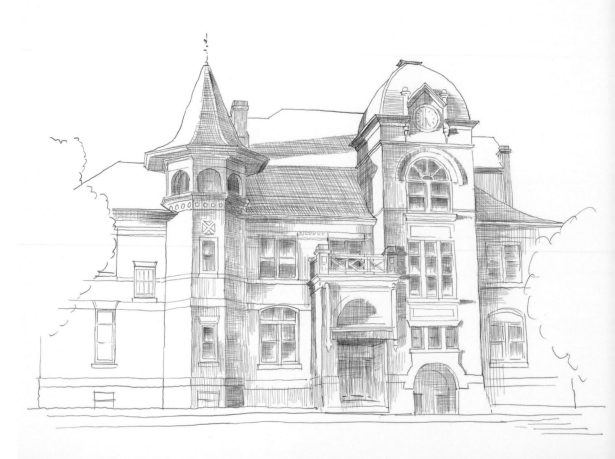

The final level of value will require still more hatch patterns, often at an angle to complete patterns that are vertical and/or horizontal, as well as heavier pressure on the pencil. This stage is where the real visual depth comes from, with the darks becoming quite dark. The intensity of contrast should increase around the main area of focus—in this case the central part of the drawing. As you complete the drawing, try to reinforce the edges defining the greatest shifts between dark and light, and touch things up such that all the patterns are blended into tones rather than appearing only as groups of lines.

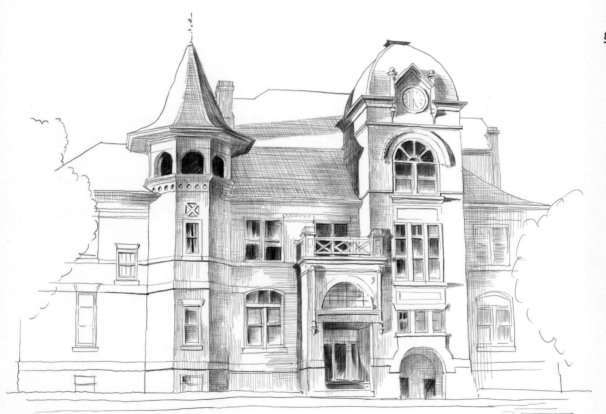

Small, Quick Studies

An excellent way to develop your eye and hand for seeing and sketching dramatic contrast is to practice small, quick value studies like those shown below. All four are views of streets in Rome, each of which was completed in just three or four minutes at a quite small size (about 2–3 inches/5–7.5cm maximum dimension).

Whereas the drawings on the preceding pages show a methodical approach to building value, almost the opposite is shown here. Both approaches are important to practice, as quick studies have some unique advantages.

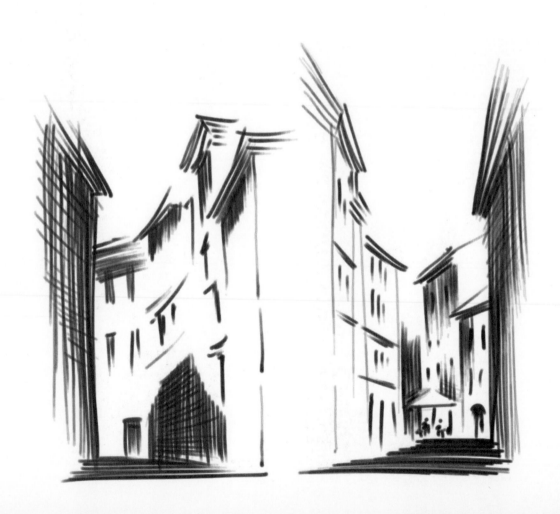

While long studies will allow you to indulge in a penchant for detail (if that's something you enjoy), brief studies can help you learn how to focus on the big picture, using more energetic strokes in far less time, but still arriving at a truly compelling image. They limit your ability to become bogged down in detail—if the sketch is very small and very fast, there is simply no time or space to draw insignificant elements in the view. Instead, your focus will be on big, bold strokes that are only about applying darkness in ways that relate fundamentally to the perspective and the character of light in the scene.

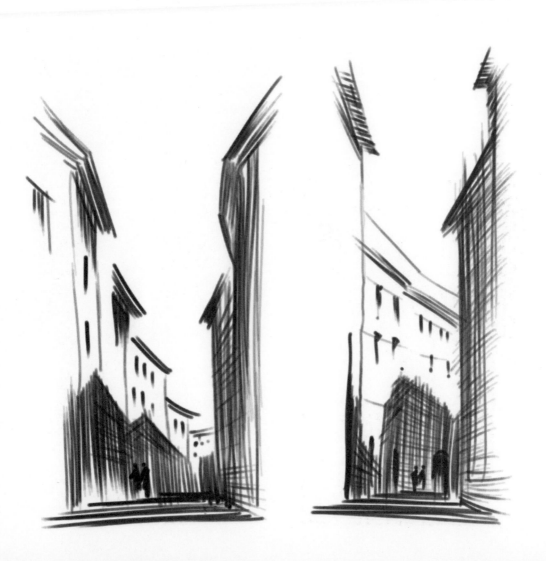

Forcing Shadows

Drawing is about editing—emphasizing some aspects of your view while de-emphasizing or even eliminating others—for the purpose of creating a compelling or informative image. When it comes to value, this is often achieved by "forcing shadows," which is an old expression that means accentuating the direct contrast between dark and light edges in a drawing. With a too-consistent pattern of hatching and cross-hatching, as seen in the image on this page, there is little indication of the variable character of light that is usually present in shadows.

Seeing this in your subject can require careful observation, but there is usually some gradation to cast shadows and surfaces that are in shade. It can help to exaggerate this variation—at least a bit—to give a better, more interesting sense of depth in the drawing.

The greatest contrast in a drawing should be along the lines where dark meets light. In areas away from the leading edge of a shadow, there is often some light being reflected from other surfaces and lightening the deeper parts of the shaded area. To represent this phenomenon in a drawing, we "force" the edges of the shadows and grade away from the edges.

More specifically, wherever the edge of a cast shadow or a shaded surface meets direct sunlight, emphasize the contrast as much as possible. Make this edge very dark, and then grade the darkness as you move away from this edge—that is, make it gradually lighter as you go. It might require a few layers of hatching, and a few passes over the same area to really build up the darkest edge and to ensure a reasonably smooth transition to the lighter areas of the shading.

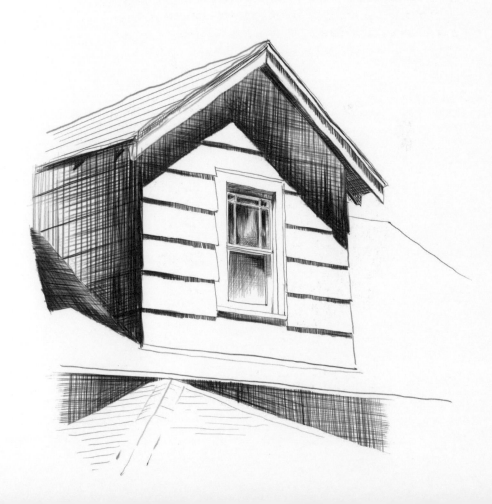

Value and Distance

As objects recede into the distance, they will typically show less value and distinction. This is known as "atmospheric perspective," because dust and water vapor in the air will diminish the sharpness and overall value of what we see far away from our drawing position. This can be especially apparent when there is a significant depth of field, with some objects relatively close to us, some in the middle-distance, and some quite far in the background.

In this example, the trees in the foreground are very dark and also clear with respect to detail. In the distance, we see more trees on a hillside, but these are relatively faint and show less detail. The objects in the middle distance—the buildings—show a more complete range of both value and detail. By adjusting the way objects are drawn, and particularly the strength of their respective values, we can accentuate their positions in space.

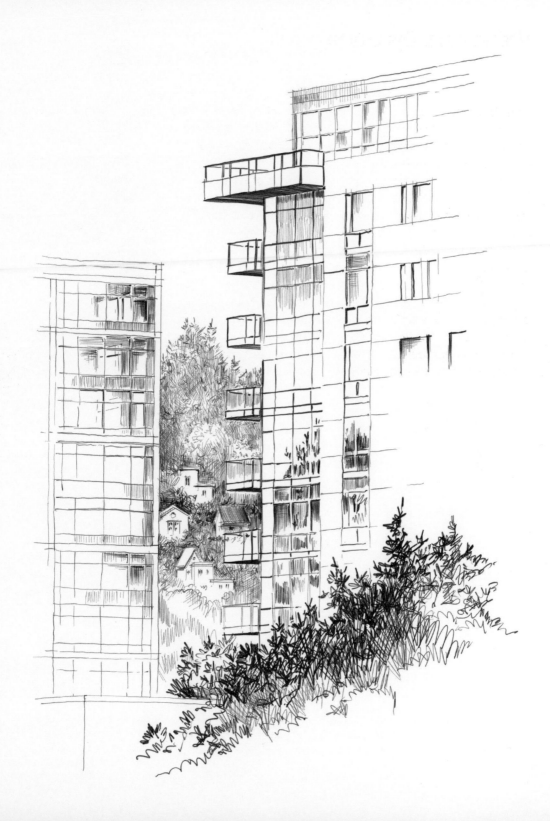

Increased Detail in Shade

A different strategy for applying value involves showing
a greater amount of detail in shaded areas of a building.
If we were to draw all the bricks in the example shown
here, the level of sunlight being shown would be greatly
diminished. Even if we only drew the mortar joints between
the bricks, the resulting lines would create a pattern that
would begin to read as shading, even if the surface is in
sunlight. By emphasizing the material surfaces that are
actually in the shade, it's possible to convey the nature
of the materials without compromising the brightness of
the parts of the building that are in direct sun.

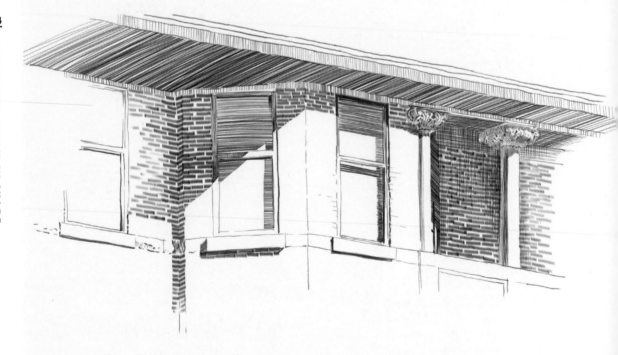

It helps to practice drawing a variety of standard building materials such as stone, bricks, shingles, wood, and similar materials. Practice drawing them with varying dimensions and construction patterns, with a range of values for each; these practice patterns will come in handy when you're actually outside drawing.

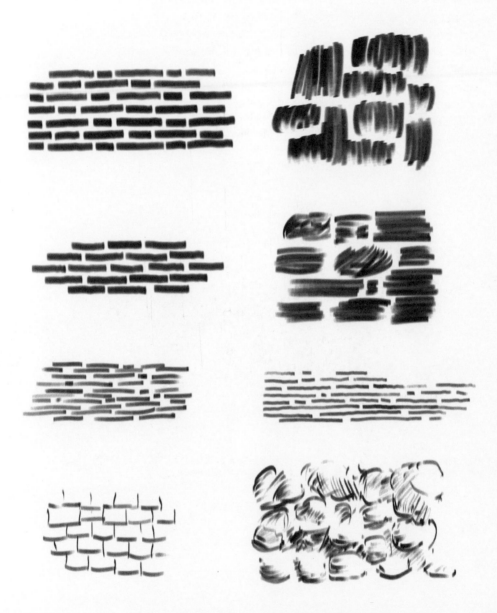

Drawing at Night

At night, with only artificial light to work with, objects in view will be less clear, and the darks will tend to blend into one another, making it difficult to draw distinctions among elements. Nocturnal drawings also require a significant amount of graphite or ink on the page, because so much is in darkness and relatively little will be in light. Begin by laying out the drawing as usual—shown here on the left side of the image. Then use a much broader stroke to lay down the large areas of darkness, being careful to reserve the white of the page for the highlights.

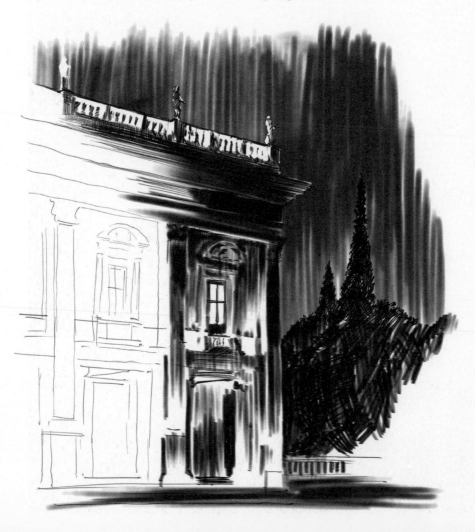

An alternate way to approach drawing at night is to use dark or black paper with a white pencil. Once again, set up the drawing as usual, with light lines defining the major edges and composition of the view. A broad stroke is less necessary in this instance, because you'll be drawing only the elements that are illuminated—in this case from within the windows and from artificial lights shining upward on the architecture. A broad stroke comes in handy for the sky, though, to silhouette foreground objects like the trees and the building's profile, which would otherwise be indistinct due to a lack of contrast.

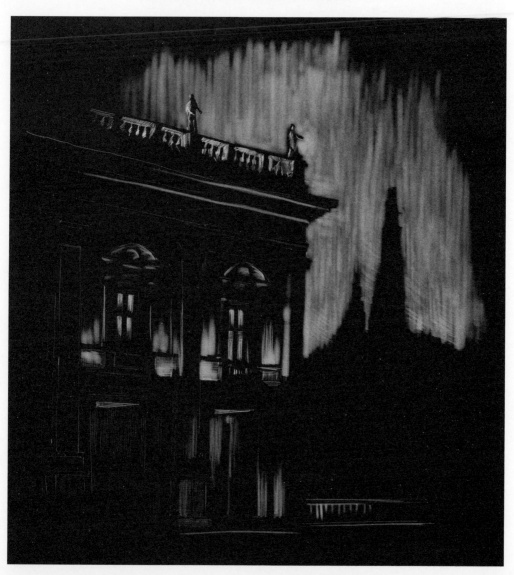

ENTOURAGE

The word "entourage" is used to refer to the elements
of architectural drawing that are additional to the
architecture itself—people, trees, street furniture, vehicles,
and the like. While our drawings are focused on buildings
and urban spaces, if we neglect to show any entourage
then our drawings will lack the life that permeates our
cities. This chapter is intended to help enliven your
drawings by providing some fairly simple ways to
draw the people and objects that surround us.

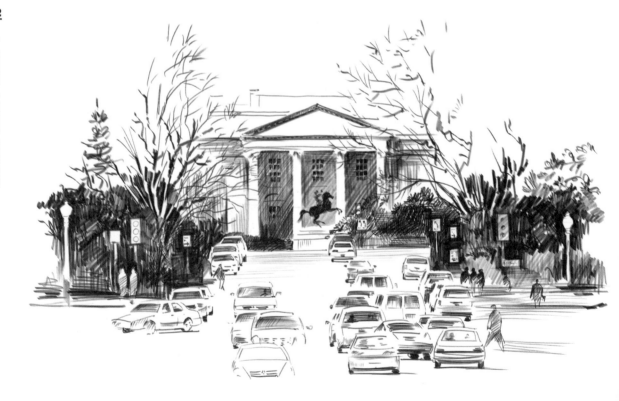

A Word About Editing

Always keep in mind that a significant aspect of drawing
from observation involves deciding, as you go along, to
leave some things out. Don't try to draw everything you
see. This is especially true if your interest is in the
architecture and the urban spaces of cities, in which
case you might begin to omit some of the extraneous
elements in your view as a way to emphasize the real
focus of your drawing. Lamp posts, benches, an
overabundance of trees and shrubs—these particulars
are certainly part of our environment, but they can be
a distraction from the more general elements of the view.
The drawing on this page shows enough entourage to
provide some context, without going overboard with the
cars, signs, and trees.

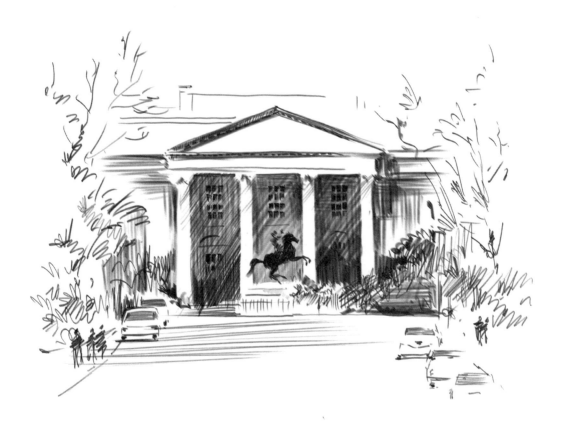

People

To give your drawings an appropriate sense of life, it's
often essential to include at least some human figures
in the view. For a variety of reasons, though, people can
be very challenging to draw convincingly. One of the
problems is that we often try to give them too much detail
by drawing faces or hands, rather than being satisfied
with indicating an overall shape that clearly represents
a human form. At the other end of the spectrum, we
sometimes don't provide enough visual information, but
try to get by with drawing "stick people." This section will
focus on striking a balance between too much and not
enough, giving you some shorthand techniques for
including figures that will add to the drawing rather
than detract from it.

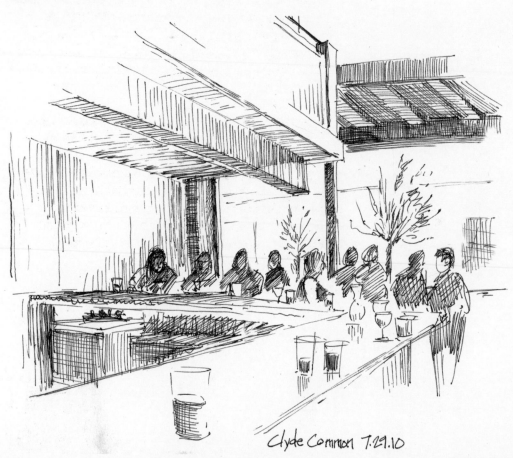

Clyde Common 7.29.10

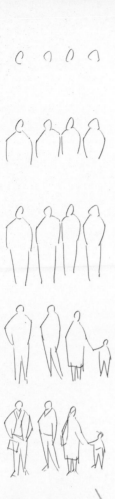

Basic forms: The human body is fantastically complex, yet it's important to develop some techniques for simplifying this form. The essentials of a standing figure can be boiled down to the head, the torso, and the legs. I typically think of this abstraction as seven individual marks on the page—a somewhat oval shape for the head, a pair of quick strokes for the shoulders, another pair for the sides, and two more that define the outline of the legs. The proportions can vary a bit, but it's usually assumed that the figure is roughly seven or eight head heights—this is one of the reasons I begin by drawing the head first, and then drawing the rest of the body to work proportionally from this starting point. Practice these simple shapes repeatedly, until you can very quickly sketch forms that are believable.

Developing variation: Another aspect of "believability" is variation—if all of the people look exactly the same, they will appear static and less human. It doesn't take much too suggest slightly different heights, weights, clothing types, or hairstyles, just by manipulating the basic seven strokes and adding just a few more marks before finishing with some hatching.

Groups versus individuals: I typically find it easier and more convincing to draw people in groups rather than trying to draw single figures. It's also a subtle way to indicate some sociability in your drawings—that people are meeting, talking, walking together, and so on.

Groups of people are drawn in much the same way as individuals, but with fewer lines because they can be blended together. In this way, drawing people in groups is both effective and economical.

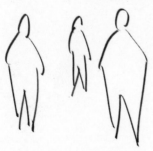

People Viewed at Eye Level

Imagine all of the human figures in your view are standing on the same level surface as you, and you are all standing, as is often the case when sketching in cities. Begin by drawing the horizon line, which will coincide with the eye level of all the figures. Then draw rough circular outlines for the heads, followed by just a couple lines that suggest shoulders and torsos.

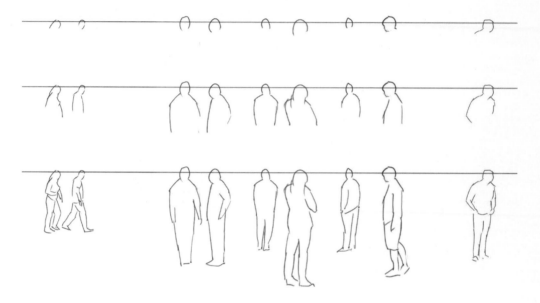

Complete the outlines by bringing their legs to the ground. By keeping all the heads roughly aligned along your eye level, you can indicate distance by making the figures larger (closer to your point of view) or smaller (farther away). Once the outlines have been established, a bit of value can be added to give the figures a sense of three-dimensionality.

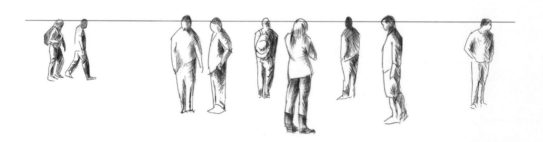

People Viewed from Above

When you're looking downward, the heads of human figures don't align along the eye level, so you can feel free to distribute them in ways that add life to the scene. Just keep in mind that the farther away they are, the smaller and more abstract they'll appear (in other words, they will require less detail).

The same process for drawing the figures applies—start with a simple outline for the head, followed by the shoulders, torso, legs, and feet. Add value as necessary, but try to keep detail to a minimum (especially for faces and hands).

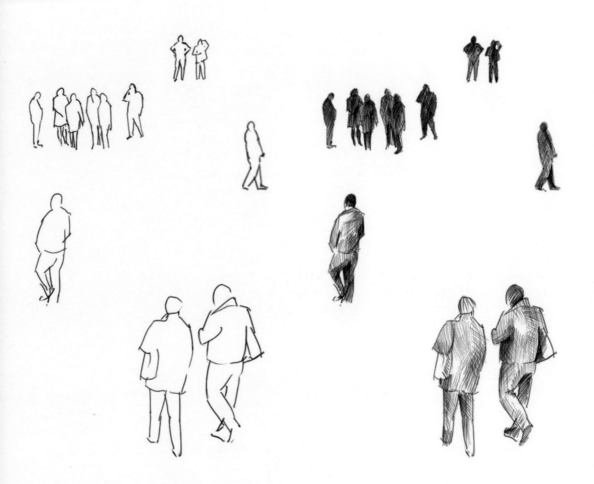

Counterpoint: As with all aspects of your drawing, it's a good strategy to consider contrasting lights and darks as you're developing the sketch. If the background is going to be light, make your figures dark, and vice versa, otherwise the people in your drawings will tend to get lost in their surroundings.

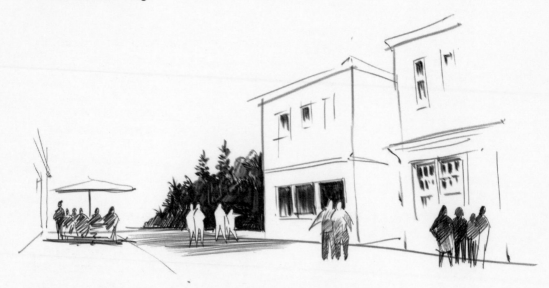

Indicating action: Just a few small gestures, props such as bicycles, or some indication of a striding figure can help to enliven a view by suggesting that you've captured a moment of action. It doesn't take much, so try not to overdo it. Also, a bold horizontal stroke or two at people's feet will ground them and indicate a shadow, even if the figures are kept very simple and without much indication of light and shade.

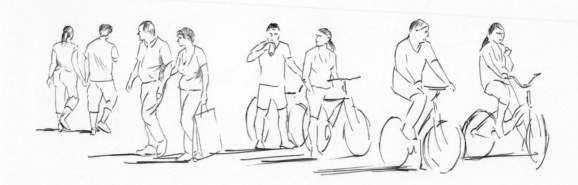

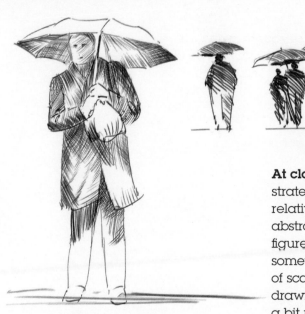

At closer range: While it's a good strategy to keep human figures relatively simple, or even somewhat abstract, there are times when a figure or two at close range will add something to the drawing—a sense of scale or distance with respect to the drawing subject, for example, or just a bit more specific character about the place. In these cases, it's usually wise to draw figures from behind, so you'll be less likely to get caught up in trying to create an accurate portrait, and less prone to the frustration of not capturing someone's likeness. In any case, strive to keep the forms and shading relatively simple.

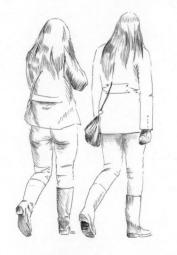

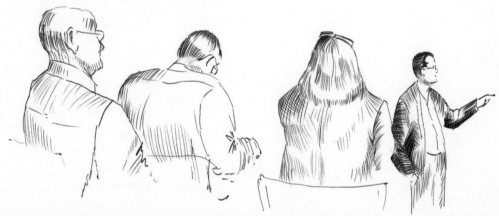

Vehicles

As with buildings, drawing vehicles is much easier if you start with the basic outline and only fill in the smaller scale elements after the overall shapes are established. Although vehicles tend to have numerous curves, it's usually better to rough out their forms with relatively straight lines initially, and then develop the curving lines on this framework. Practice drawing vehicles from various points of view, and try to avoid getting into too much detail.

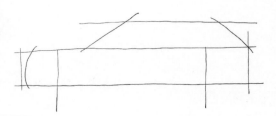

Begin with the major horizontals at the top, middle, and bottom of the vehicle.

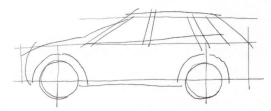

Continue with rough circles for the wheels and add diagonals to suggest the passenger compartment.

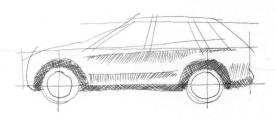

Use general hatch and cross-hatch patterns to clarify the darks, but leave most of the car light.

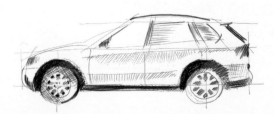

Finish with some strong darks around the wheel wells and undercarriage.

Always start with the basic framework, using lightly-drawn guidelines that will map out the entire image.

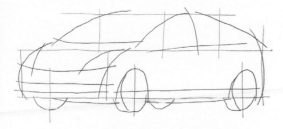

Develop the structure of the drawing by adding a second layer of guidelines, paying closer attention to the contours of the vehicle and the orientation of the wheels.

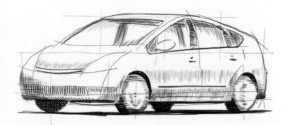

Add hatch patterns, making the strokes in the direction of the car's surface, using curving hatch patterns, if necessary.

When drawing groups of vehicles, see how little you need to put on the page to indicate their presence. Just a few lines, some simple hatch patterns, and a bit of strong darkness below—this is all that's necessary to convey the essential elements of cars and trucks. Keeping things simple like this will prevent the vehicles from overpowering the rest of the drawing.

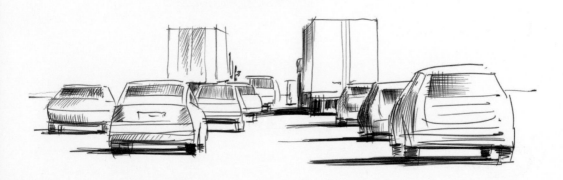

Vehicles Aligned Along the Curb

It's very common to want to include a number of vehicles parked along the curb in a typical city street view. Here are some strategies to practice and keep in mind.

Guidelines: First, always try to begin with a simple set of guidelines that establish the locations of elements common to most (or all) of the vehicles in view. Here, I've drawn one line where the tires all meet the pavement, another that's roughly at the height of the roofs, and one more that's at the level where the windows meet the lower bodies of the cars. These three lines don't look like much on their own, but it's critical to draw them first as a way of unifying the row of vehicles.

Further form: In steps two and three (above and below), we begin to define the somewhat boxy shapes of the upper and lower bodies, while drawing another roughly horizontal line at the level of the undercarriage (making sure to leave space between this line and the line of the ground below). Notice that all of the vehicles in the view are being developed at the same rate—we're not getting into any detail yet, but instead we're drawing only the rough outlines of all the vehicles.

Additional form and adding the wheels: Continue the process of drawing lines to help flesh out the general forms of the cars, but don't go too far—keep them fairly simple and avoid detail. I typically add the wheels last, so they have somewhere to go—a framework into which they can be placed more accurately.

Finish with value: After patiently developing all of the vehicles at the same pace, we can finish the sketch by adding just enough value to give the image some three-dimensionality. Pay special attention to the darkness beneath and within the vehicles—the tires will be quite dark, while the undercarriage, ground, and interior of the roof can each be shown with a dark horizontal line.

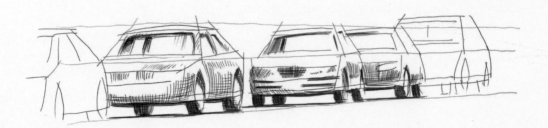

Trees and Hedges

Landscape elements can add a lot of life to drawings of cities and buildings, but if they're not handled carefully they can also detract from an otherwise well-crafted image. The difference is made by applying simple yet convincing patterns rather than merely scribbling to indicate foliage. Practice drawing patterns like these (right), in various directions and at various densities, until it becomes easy to generate tones that can be combined into forms that read as trees and shrubs.

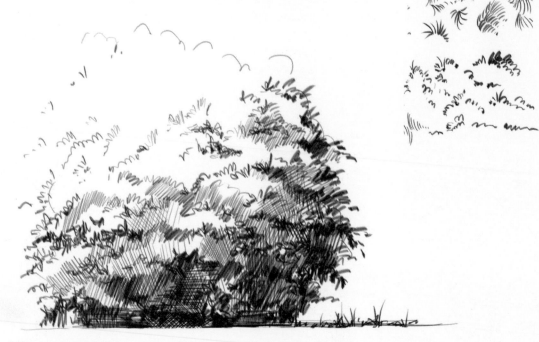

Mass and Light
Build up the masses of trees and hedges by repeating these patterns, but avoid filling in shapes with the exact same pattern at the exact same value, as this will detract from the sense of depth and light in your drawing. Consider the direction of sunlight and emphasize the three-dimensional forms of plants by keeping the upper portions light and adding darkness underneath. Hatch and cross-hatch patterns can be used to add additional value and unify the masses of foliage.

Basic Tree Forms

In drawing the basic tree shape, the stereotypical "lollipop" is actually a good place to begin, provided you don't stop there. Just a bit more information will go a long way toward a much more convincing image. Give the trunk some character and taper toward the top, then bring the limbs and smaller branches upward and outward to complete the form.

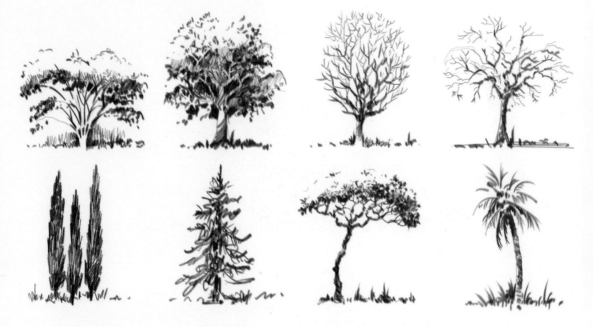

Pay attention to the essential differences between deciduous and coniferous trees, and the variety of species in each category. Develop some simple techniques you can rely on when you're out sketching—combining foliage and hatch patterns with basic tree forms.

Perspective

Trees and hedges, when arranged in rows, will conform to lines of perspective in your view. Use guidelines to link the tops of the canopies, the point at which trunks meet the ground, and where the trunks branch out into limbs. Hedges that have been trimmed into parterres will benefit from lines that define their edges and corners, and these will be related to the lines of perspective convergence.

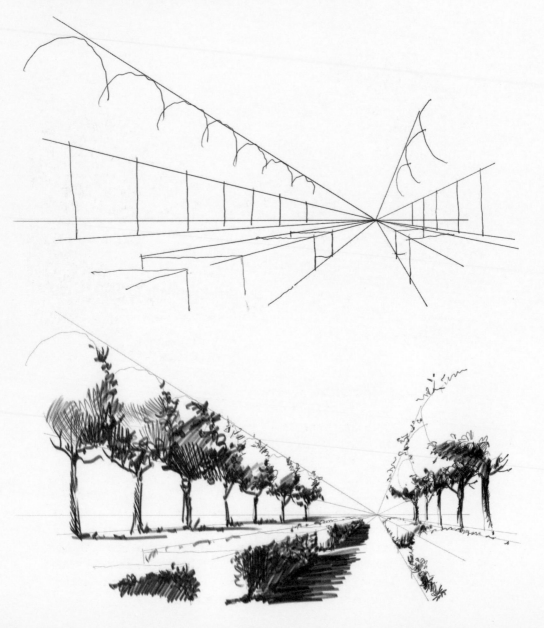

Combining Elements

As you place landscape elements in your view, avoid
drawing each tree or shrub as a complete object. Draw
only enough to indicate its presence and how it relates
to the rest of the view, and focus on variations in value
and scale. Distant objects will appear more simple, while
objects in the foreground will show increased detail—
for example, try adding some close-up and silhouetted
branches and leaves in the upper corners as a way to
frame your view and give an added sense of depth. Most
of all, have fun making marks that are loose and varied,
and be patient as these marks build into a convincing
image of foliage and landscape.

Street Furniture

When we pause to have a coffee or something to eat, the street becomes our social space. The furniture and decorations that compose these urban rooms can contribute greatly to the sense of life and scale in a drawing. Benches, tables, umbrellas, and the like can have similar lines to architecture, but they can also be somewhat more organic. Try to keep your focus on the general nature of the drawing, and don't feel compelled to draw every park bench or other bit of furniture you see—editing out some elements can be a good way to shorten the time spent on a particular drawing and also a way to keep the focus on the buildings and spaces. Even if you do try to include a good amount of street furnishings, see how little really needs to be drawn in order to get the point across.

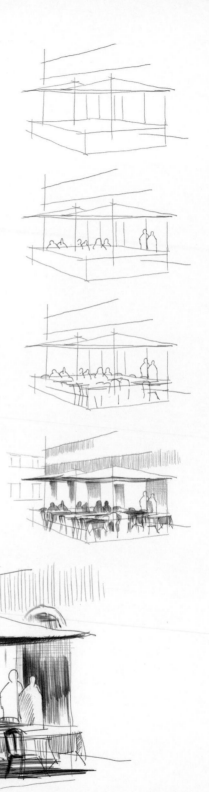

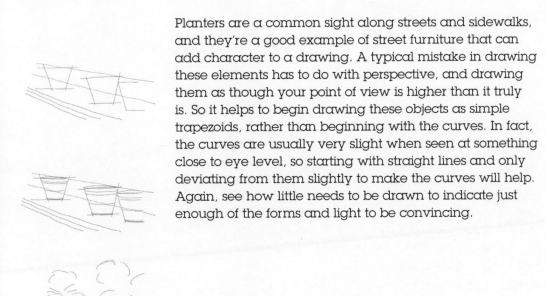

Planters are a common sight along streets and sidewalks, and they're a good example of street furniture that can add character to a drawing. A typical mistake in drawing these elements has to do with perspective, and drawing them as though your point of view is higher than it truly is. So it helps to begin drawing these objects as simple trapezoids, rather than beginning with the curves. In fact, the curves are usually very slight when seen at something close to eye level, so starting with straight lines and only deviating from them slightly to make the curves will help. Again, see how little needs to be drawn to indicate just enough of the forms and light to be convincing.

Signage

Our cities are littered with signs of all types. Trying to
draw every sign as it appears would take much or all
of our allotted drawing time, and it wouldn't necessarily
make for a better drawing. At some point it becomes
too much information, and can actually interfere with
what we're trying to capture in the sketch. If your
primary interest is in signs, then of course you should
spend your time drawing them, but if you're trying to
draw street scenes that include a balance of visual
information, consider editing out some or all of the
signage you encounter.

 In the example on this page, I've
tried to draw all the signs in a view of
a street in Portland, and doing so took
considerably longer than 15 minutes!
It's an interesting drawing, if only for
its abundance of detail—in other
words, there's a lot to look at.

But to my eye, the drawing lacks focus—it's not clear what the intention is, or what is supposed to be the most important aspect of the view. But if we begin to edit, and be more selective about which signs we include, they no longer dominate the scene—allowing the drawing to develop a more apparent focus, such as the variety of buildings along the street. On this page I've eliminated all the signage, and even the telephone poles, from the view. Compare the two drawings and think about the effect of including or excluding signage.

If you do decide to include signage in your drawing, pay special attention to the character of the lettering, or fonts, that you see. They don't need to be perfectly precise in your drawing, but the distinctions between different types of text will make them far more believable.

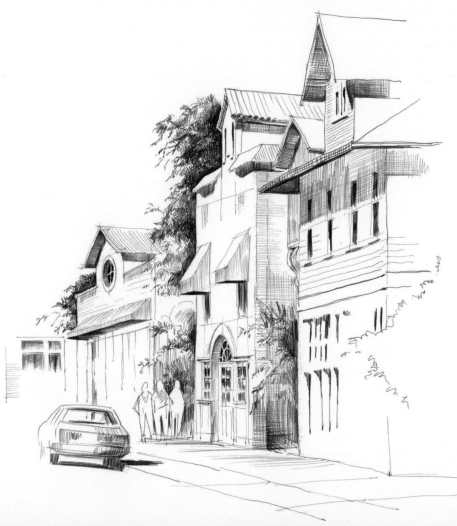

CONCLUSION

Bringing it all Together

Each and every sketch, no matter how small and no matter the subject, is a step along the way toward developing the skill to draw with confidence in any given situation. Drawing is a practice, something you do frequently and repeatedly, that builds on itself over time. It's not about making pretty pictures, though you will do plenty of that as you go. It's much more about the daily observations you make through the act of drawing, and the more direct way of engaging with the world than most people experience.

Take the topics in this book individually, and practice them on a regular basis, such that you're improving in your ability to select appropriate subjects, deal with composition and perspective, apply value to describe light and shade, and enrich your drawings with entourage. Don't feel compelled to do all these things in every drawing, but do work toward an approach that will eventually bring these aspects of drawing together in a reasonable amount of time—perhaps only 15 minutes.

As a conclusion to this book, what follows are some ideas and tips that should help you develop drawing as a practice, and to continue and expand upon your own learning process.

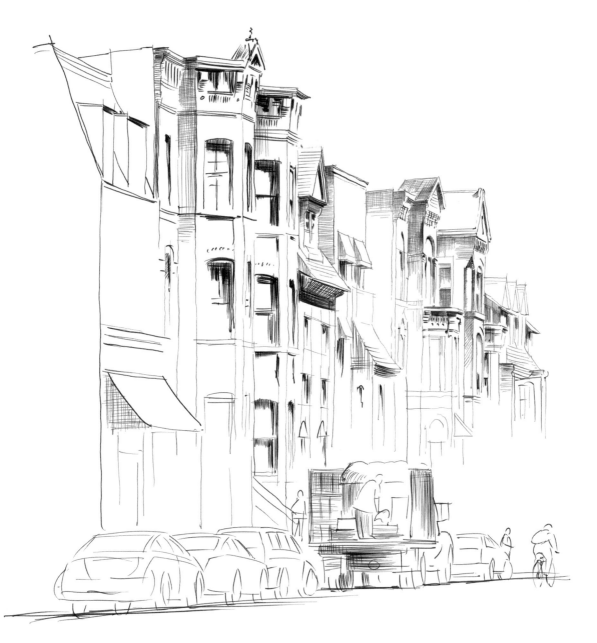

Dealing with Frustration

One of the greatest killers of motivation to practice is the sense that you can't draw as well as you expect to. This frustration will always be part of drawing, but it should be matched by a sense of achievement along the way. This begins with the understanding that not every drawing will go your way—some will seem to work well, while others will not. This is actually one of the things that has kept me drawing for many, many years—that fact that it's not always easy. But there are proven strategies that will help you to succeed more often than "fail."

First, let's dispense with the entire idea of "failure" in the context of drawing practice, because it's simply not helpful. Whether or not you're happy with the results of any given drawing, it's still—always—a step toward improvement, particularly if you're thoughtful about how and why things may have gotten off track. Often, the best thing to do when frustration hits is to merely turn the page and start again, because no single drawing should be seen as being terribly important in itself, but rather in the context of your continued development.

However, it's even better to do some brief analysis, so if you feel dissatisfied with a drawing, get in the habit of asking yourself why. If you can begin to specify the reasons for your dissatisfaction, you'll be able to spend time working toward real solutions rather than just being frustrated in a broad sense. It also helps immensely to identify parts of the drawing that you feel are successful. I do this for virtually every drawing I create, and it really does help to offset feelings I may have about not making sufficient progress.

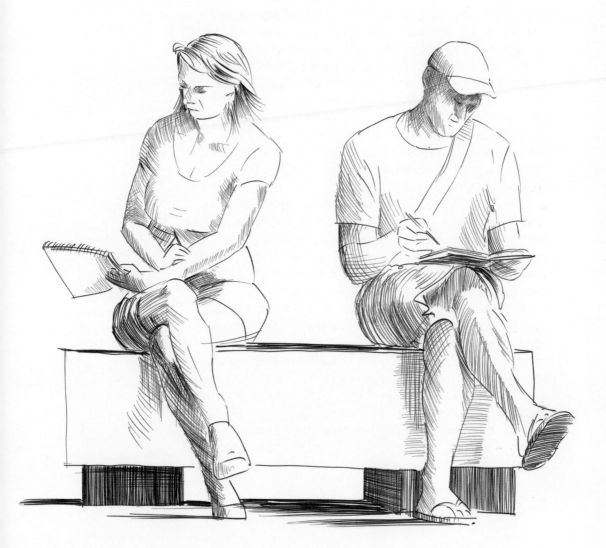

Much of your frustration will likely be related to the time you spend drawing, or the pressure you might feel regarding the time spent to achieve a drawing that satisfies.

Don't worry so much about not completing a given sketch or drawing. Always begin with the process described earlier in the book, with regard to time, scope, and size, and this will be less of an issue. But if you do get in over your head and take on too much in a given drawing, just do your best with it before you need to pack up and leave the scene. Also, don't feel compelled to continue working on an unfinished drawing when you've had to leave the subject's location. Certainly, if you have the time and motivation to keep working on it, go right ahead, but sometimes it's better to leave it unfinished and chalk it up to experience. You'll know better next time how to bite off what you can actually chew while you're on site.

Being decisive about what to leave out of a drawing can also help prevent frustration. In the drawing at right, my focus was on the towers above the theater entrance. The adjacent buildings are interesting, but not fundamentally what the drawing is about—so they're drawn very sparsely. Their essential outlines are visible, to provide some context for the central focus, but that's about it. This is the kind of decision you'll need to make almost every time you draw, and the more effectively you make little decisions like these, the more likely you'll be to feel satisfied with your effort.

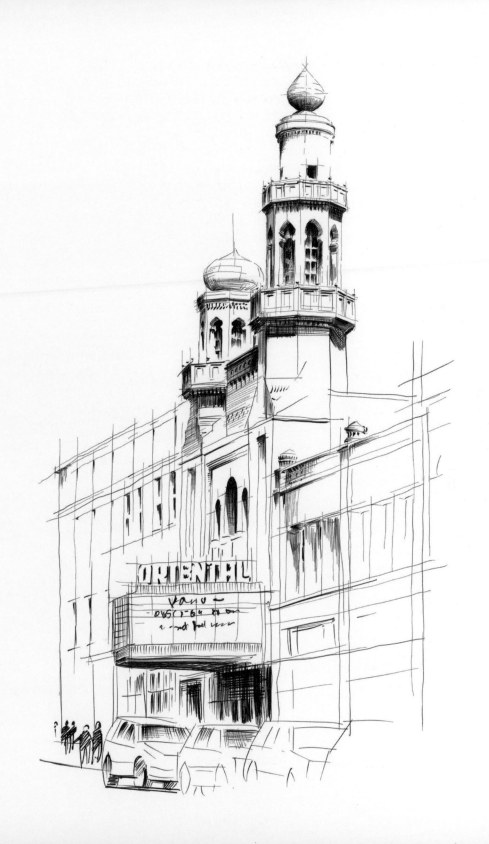

Perhaps the most important overall strategy for working through frustration is to draw regularly, with a brief sketch or two every day if possible. If the individual drawings are of short duration, as suggested by the title of this book, you should be able to incorporate your drawing practice comfortably into your daily life and, most importantly, to experience some steady progress.

Date each and every sketch as a way to track this progress over the months and years. Challenge yourself to complete sketchbooks—that is, to fill the entire book—as a way to establish longer-term goals for the practice.

Part of your ongoing effort should be toward getting into regular, good habits, so focus on the fundamentals presented in this book, with as much repetition of the basic skills as possible, applied to a wide variety of subject matter. Another part of your effort should be focused on stretching your abilities further. What follows is a series of approaches to doing just that—continuing to learn as long as you continue to draw.

Continuing the Learning Process

While there is no substitute for frequent and diligent practice, there are strategies that will lead to ever-increasing levels of skill and ever-broadening approaches to technique. To continue developing your drawing ability, it's important to stay focused on the tasks of learning. If we only sketch without actually challenging ourselves to continually improve, then our ability is very likely to stagnate and perhaps lead to frustration or at least a sense of boredom. Not all who draw are very interested in constant improvement—some will be content with their skills just as they are. But if you'd like to work on developing your drawing abilities over time, here are some simple strategies that will help.

Stretch yourself in terms of subject matter or format. If you find yourself always drawing the same sorts of things in the same way each time, try to mix it up at least once in a while. Change your typical point of view, or the scope of your subjects, or the typical orientation of the drawing on the page. Whatever you find yourself doing out of habit, try doing it differently on occasion. The drawing on the page opposite is not my usual subject matter, or at least the point of view is more extreme than I would typically attempt. But it was a satisfying challenge to draw something new, to employ some perspective skills, and to avoid getting too bogged down in the detail.

Study the work of other sketchers, and try to apply their techniques to your own work as an exercise. This book would be the obvious place to start, but there are a great many books and other sources containing a wide variety of examples, in all sorts of drawing styles. If you only work from a single source, it may be true that your approach will become a bit too similar to that person's way of drawing. But as long as your source material is widely varied, there's absolutely no reason to fear developing an approach to drawing that isn't truly your own. This is an excellent way to learn new techniques and build your repertoire of sketching skills.

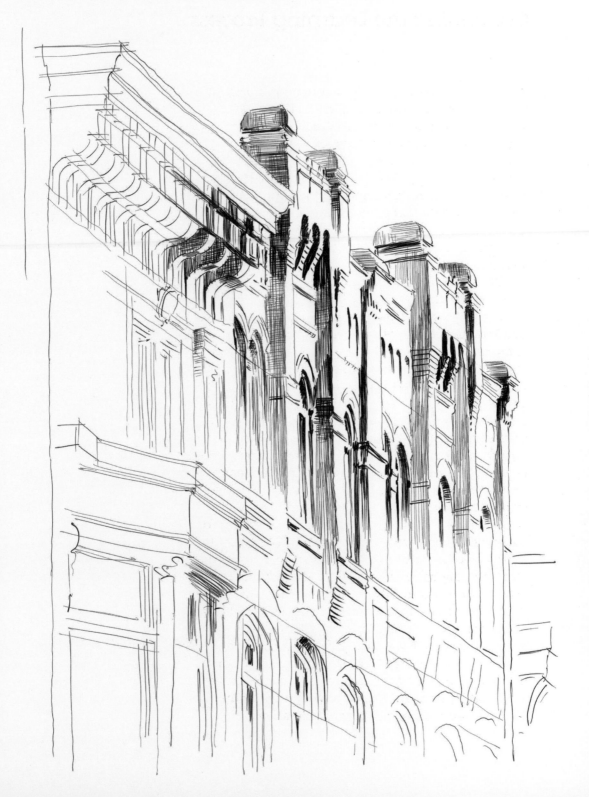

Carry images of sketches you would like to learn from, and keep a few of these in your sketchbook to refer to them while you're actually out sketching. If you find yourself struggling with particular elements of drawing, seek out examples of those elements that you think are worth emulating. Make some small copies of these references to carry with you—it might be several sketches of trees, for example, or cars, or whatever else you want to refer to when you're drawing.

Draw small, using preliminary thumbnail sketches to explore composition and value. More frequent, shorter duration sketches are generally better practice than larger, longer, less frequent drawings.

Try using media that you haven't used before, or haven't used in some time. When you begin to feel very comfortable with a particular medium, it may be time to try something else for a while. Transfer the knowledge you develop from one media choice to another. For example, when you begin to use color (and particularly watercolor), always strive to achieve the same levels of value that are possible, and relatively easy to achieve, with graphite or ink.

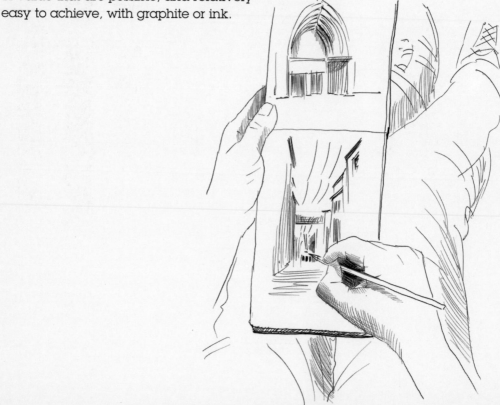

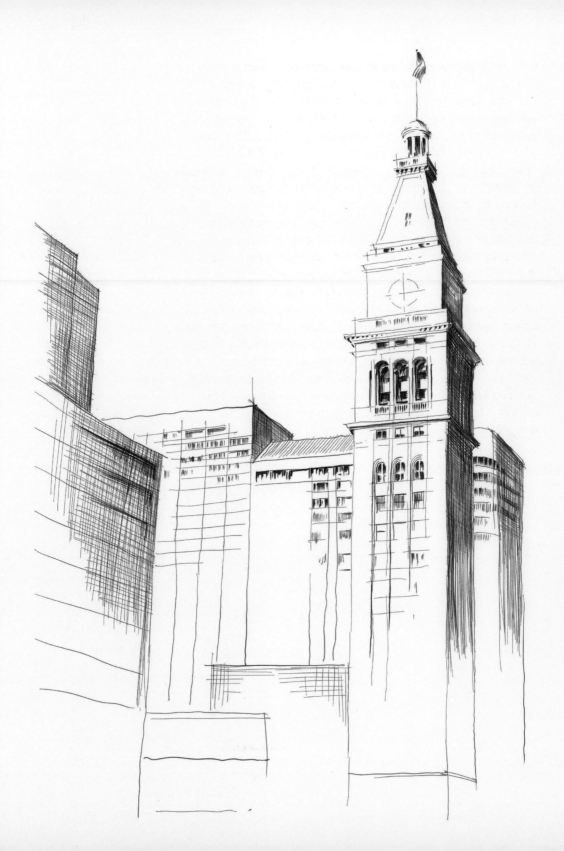

Finally, invite honest criticism of your drawings, and avoid the tendency to be protective or shy about your work. One way to make this happen is to attend local drawing events, sometimes called "sketchcrawls," where people of all experiences and abilities gather to draw in the same place and then discuss their drawings as a group. If this sort of event isn't available where you are, another excellent way to share your work is through the internet. The ease of communication provided by the web over the past decade or so has opened channels among sketchers around the world. There are many forums for sharing images and discussing the work, and in my experience, these forums are very "safe" places—full of support, generosity of spirit, and an abiding passion for drawing.

The more frequently you draw, the more you pay attention to the practice of drawing, and the more you get out there among other people who draw, the more swiftly and surely your abilities will advance.

References

Any single book about drawing can only cover so much ground, and will be limited to the author's knowledge and experience at the time of its publication. Hopefully this book has provided you with a strong start toward building your drawing skills and confidence. As you continue, there will be times when you'll need additional direction. The books listed here represent a selection of works that I've returned to on many occasions to push my own abilities further.

I've found that some of the most valuable texts are ones that have been long out of print. The books of Arthur Guptill, Ted Kautzky, and Ernest Watson, in particular, are an incredibly rich source of technique, inspiration, and examples, perhaps because they were written at a time when the general rigor applied to the practice of drawing was considerably higher than it has been for many years since. Although some of these books are out of print, copies may be found online, for sale through sellers of used books or for free in digital format.

Online forums are an excellent place to see and study the work of other artists, and also to share your own work as you develop your skills. Online video courses are becoming more widely available, particularly through platforms such as Craftsy, where the instructors are available for questions and feedback. There are numerous additional online venues where you can learn about drawing, view the work of others, and even find other people in your geographic area who enjoy drawing. Urban Sketchers is a non-profit organization "dedicated to fostering a global community of artists who practice on-location drawing," and it's really the most comprehensive site of its kind on the web. The Worldwide SketchCrawl is an event that happens a few times each year, and it gives people all over the world a chance to get out and draw together on the same day, then post their work in a geographically-arranged forum. The more you strive to participate in drawing and learning through these venues, the more connected you'll be to the ever-expanding community of artists around the world.

Graphic Journaling, Moh'd Bilbeisi
Kendall Hunt Publishing Company: Dubuque, IA, 2009.

Sketching on Location, Matthew Brehm
Kendall Hunt Publishing Company: Dubuque, IA, 2012.

Drawing Perspective: How to See It and How to Draw It, Matthew Brehm
Barron's Educational Series, Inc.: Hauppauge, NY, 2016.

Architectural Graphics, Francis D.K. Ching
John Wiley & Sons: New York, 2009.

Sketching and Rendering in Pencil, Arthur L. Guptill
The Pencil Points Press: New York, 1922.

Pencil Broadsides, Theodore Kautzky
Van Nostrand Reinhold Company: New York, 1940.

Architectural Sketching and Rendering, Stephen Kliment
Whitney Library of Design: New York, 1984.

Freehand Sketching, Paul Laseau
W.W. Norton: New York, 1999.

Architectural Rendering Techniques, Mike W. Lin
John Wiley & Sons: New York, 1985.

Basic Perspective Drawing: A Visual Approach, John Montague
John Wiley & Sons: New York, 1998.

Pencil Sketching, Second Edition, Thomas Wang
John Wiley & Sons: New York, 2002.

The Art of Pencil Drawing, Ernest W. Watson
Watson-Guptill Publications: New York, 1968.

Author Blog: brehmsketch.blogspot.com

Author Flickr Page: www.flickr.com/mtbrehm

Sketching Essentials Course: www.craftsy.com/ext/MattBrehm_10190_F

Urban Sketchers: www.urbansketchers.com

Worldwide SketchCrawl: www.sketchcrawl.com

Acknowledgments

Many thanks are due to all those who have helped me understand the process and value of drawing over the years, including numerous teachers and students. My colleagues and administrators here at the University of Idaho have been understanding and supportive as my time commitments have, at times, needed to be refocused on longer-term book projects such as this. My deepest thanks go to my family—my sons, Will and Sam, and my wife, Patty—who have provided their love, support, patience, and friendship over the years as I have developed my career in drawing and teaching.